Japanese
Woodblock Prints
in Miniature

Japanese Woodblock Prints
in Miniature : The Genre of
SURIMONO

by Kurt Meissner

CHARLES E. TUTTLE COMPANY
Rutland · Vermont : Tokyo · Japan

Representatives

For Continental Europe: BOXERBOOKS, INC., *Zurich*
For the British Isles: PRENTICE-HALL INTERNATIONAL, INC., *London*
For Australasia: PAUL FLESCH & CO., PTY. LTD., *Melbourne*
For Canada: M. G. HURTIG, LTD., *Edmonton*

Published by the Charles E. Tuttle Company, Inc.
of Rutland, Vermont & Tokyo, Japan
with editorial offices at
Suido 1-chome, 2–6, Bunkyo-ku, Tokyo

Library of Congress Catalog Card No. 78–94024
Standard Book No. 8048 0323-4

First printing, 1970

Book design & typography by F. Sakade
Layout of plates by S. Katakura
PRINTED IN JAPAN

Table of Contents

Five : The Surimono *(Plates 1–33)*

List of Illustrations

Acknowledgments

I am greatly indebted to the Museum für Kunst und Gewerbe in Hamburg and to Dr. Rose Hempel who heads the East Asia section of this museum who gave permission to reproduce two surimono in this book (Plates 12 and 32). All other surimono presented are from my private collection.

Grateful acknowledgment should also be given to Mr. Usher P. Coolidge of the Fogg Art Museum for his kind assistance, and to Mr. Charles H. Mitchell who very kindly read the first manuscript and gave competent, useful advice for various improvements.

On this occasion I want to express my gratitude to an old personal friend, now deceased, Mr. K. Taki. When I was very young, he did much to stimulate my interest in the beauty of Japanese art and literature, thus rendering the 60 years of my stay in Japan both interesting and enjoyable.

Introduction

Hundreds of excellent books already exist on the beauty, artists, and eminent importance of Japanese woodblock prints. But most of these books mention nothing about the masterpieces par excellence, the *surimono*. A few others have only little to report. Also in some of the large collections the surimono are completely missing or else only represented by a few sheets.

By no means should the Japanese "surimono" be translated by the English words "printed matter." "Printed matter" can have many meanings and is completely unsuitable to describe a work of art. Japanese woodblock prints, particularly surimono, are on no account mere reproductions of finished pictures. On the contrary, the artist created the exact design for the lines and colours of his pictures. His exclusive aim was to create a woodblock print; these are, therefore, absolute works of art—the work of an artist.

This work limits itself to surimono art. *Suru* means "to rub"; *mono* means "thing." The meaning of the term surimono (rubbed thing) thus stems from the technique of printing. Surimono by no means equal the general *ukiyo-e* which were ordered and sold by art publishers. Rather, they were made in smaller numbers, in better quality, and for art-loving Maecenases who were experts and connoisseurs.

Surimono often had poems on them. Upon hearing a short poem recited in Japanese and by a Japanese, one may appreciate the elegant form and the softness

of the language due to the multitude of vowels in Japanese. A good translator with poetic inclinations may be able to approximate these characteristics in translation; unfortunately, however, a simple art collector such as myself cannot. Therefore, for the translations offered in this work as samples of surimono poems, I must ask the reader's indulgence.

Living in Japan for 60 years and working as manager of a machinery import company, I was able to collect surimono from time to time. Many decades have passed since the first was purchased. As time went on, the collection and knowledge grew hand-in-hand and now there is enough material for a book specializing in surimono taken from my own collection (with the exception of Plates 12 and 32 which were borrowed from the Museum für Kunst und Gewerbe in Hamburg). My collection includes albums from the years 1787, 1798, 1810, and several other undated albums in addition. My feeling is that surimono, which the well-known French expert Louis Gonse called *les plus séduisantes merveilles de l'art Japonais* (the most attractive wonder of Japanese art), deserve a presentation of their own.

—Kurt Meissner

One : HISTORY OF SURIMONO

Historical Background

Fifteen years after the battle at Sekigahara (1600) had been fought, Hideyoshi's son Hideyori had taken his own life in the burning palace of Osaka. Japan had changed. The endless wars between the daimyō were past. Now Tokugawa Ieyasu and his successors had unlimited power in all Japan, and all daimyō had to submit to the Tokugawa shōgun. Peace had come; it had been imposed by harsh laws, but was to last for 260 years.

Such a long peace left the samurai impoverished and unfit even for battle. The merchants, on the other hand, grew rich and developed a desire for beauty in life. The middle-class culture of the Edo period arose. (Edo is the ancient name for Tokyo; the Edo or Tokugawa period lasted from 1600–1867, i.e., the time during which the Tokugawa shōgun ruled over Japan from Tokyo.)

The turning point in Japanese cultural life can be precisely determined. The people who streamed to Edo after the establishment of the Tokugawa rule had considered themselves provincial until the Great Fire of 1657, which lasted for three days and turned all of Edo into ashes. Not until after the fire, when everything had been beautifully rebuilt, did they consider themselves citizens of the country's capital and residence of Japan's rulers. People in Edo were no longer dependent on Osaka and Kyoto, they had reason to be proud. The military caste still suppressed all other social classes, but people had money for pleasure, theatre, and the Yoshi-

13

wara (the gay quarters of Edo). They were in a position to decorate the interior of their homes and to purchase and collect printed pictures designed by first-class professional artists. Obviously this development did not come overnight. There were both good and bad Tokugawa shōgun. During Genroku (1688–1704), many of the arts flourished; but the sumptuary laws persisted until 1854, when Commodore Perry forced the Japanese to open the first harbours to foreigners.

Around about this time, the last great masters of the classical Japanese art of woodblock carving died. But the golden years of this art had already passed decades before. It flourished in a time when the people did not yet know freedom, when craftsmen as well as artists and merchants still belonged to the suppressed lower classes. They had to be careful not to draw any attention to themselves. In former centuries, only the princes and the Buddhist temples had been the patrons and clients of the artists. Farmers, craftsmen, and merchants did not yet play a role at that time. Not until the middle of the eighteenth century did it become apparent that merchants also had taste and appreciation for poetry, good pictures, theatre, and the like. They founded societies in which they received instruction in art and in 31- or 17-syllable poems. Congenial friends gathered there—artists, art lovers, poets, writers, craftsmen, merchants, and also a few unprejudiced samurai.

The designers of those pictures which were to be multiplied through the process of woodblock printing were called *ukiyo-e-shi*. They earned their livelihood by painting hand-coloured scrolls, wall hangings, book illustrations, placards, and commercial signs, etc., but chiefly by creating the designs for woodblock prints, i.e., the so-called ukiyo-e, pictures of the kaleidoscopic changing or "floating world." These ukiyo-e can be divided into three groups. First, there were those which were commissioned by publishers and sold commercially (they represented beautiful girls, actors, wrestlers, historical and legendary figures, and landscapes). Second, there were the erotic pictures *(higiga, shunga,* or *makura-e).* All Japanese *ukiyo-e-shi* painted and designed erotic pictures with the exception of Sharaku. Such pictures were in great demand. They were placed under the pillow of newly wed couples. Third, there was the group called surimono (摺物), pictures of a much smaller size which were distributed to friends as gifts on festive occasions, particularly at the New Year's celebration.

Of the three groups in the family of ukiyo-e, the erotic pictures represent the

elder brother who is evil and who is pursued by the police. The large-sized *(ōban)* pictures, which were sold commercially, represent the younger brother who is greatly admired by all. The surimono would be the beautiful and very elegant little sister.

Woodblock Prints Older than Surimono

The ukiyo-e art of woodblock printing is not old. Iwasa Matabei (1578–1650) was the first artist who hand-painted ukiyo-e but it is not probable that he made designs for wood blocks. The grand start of the ukiyo-e woodblock prints was launched by Hishikawa Moronobu (1618–94) who created single sheets and exquisite book illustrations, the versatility of which led to the great beginning.

Moronobu and other so-called primitive artists had been taught by painters of the Tosa and Kanō schools. Many generations of artists passing through these two schools had created magnificent pictures on silk or paper, sliding doors or screens for princes, Buddhist temples and monasteries. By their woodblock prints Moronobu and his successors brought art to the people.

The Kanō school appealed to the so-called primitives and also to much later artists far more than the solemn, dignified Tosa school. The Kanō school was known for its strong lines, most graceful in their movements—quite the same attributes which distinguish the best ukiyo-e.

The old primitive, one-coloured or hand-coloured woodblock prints today belong to the best and most valuable pictures of Japanese art. The "Golden Age" of ukiyo-e art, however, only began after the invention of the multicoloured printing method in 1765. Immediately afterwards the first simple calendar prints appeared which led to the ukiyo-e masterpieces par excellence, the surimono.

Distribution of Surimono and Influence of Art Clubs

A wood block exists showing three citizens on their way to friends to wish them a Happy New Year (printed in Rose Hempel's catalogue of the Theodor Scheiwe

Collection, no. 304, p. 182). Behind them two servants are walking with a stack of surimono. The citizens had willingly paid a good price for their surimono to the printer-artist who was highly esteemed. The plan or idea often came from art-sensitive and talented citizens, but the picture, and often the idea too, came from the painter-artist. Poems on the surimono were also written by these citizens, since they were members of a literary club called *ren* in which they practiced the art of poetry, generally under the instruction of a renowned poet.

The *ren* or *renjū* were clubs or groups which accomplished a great deal a few decades prior to and after the year 1800. The *ren* were occupied with poetry in general and with the composing of haiku (17-syllable poems), *kyōka* (comic poems), or tanka (31-syllable poems); also with music, theatre, and the collecting and exchanging of pictures. Occasionally artistic competitions with friendly *ren* were held. Members were art-loving citizens, merchants, a few *hatamoto* (samurai in the service of a shōgun), samurai, and professional artists. The names of a few *ren* have come down to us through history, especially the following: Kyosen Ren, Kiku Ren, Yomo Ren, Jōmō Shigyo Ren, Nagauta Kineya Renjū, and the Hana-gasa Ren. Leaders of such clubs were Kyosen (Kikurensha Kyosen) and Sakei, both of whom were *hatamoto*.

Another club existed which collected calendar prints and was led by the famous scholar Hirata Atsutane, one of Japan's most learned historians and writers. He wrote commentaries to the *Kojiki* and *Nihongi,* the oldest annals of Japan. Hirata was a scholar, philosopher, dramatist, and the first to enlighten the people about the rights of the imperial family. He died in 1843.

Even today haiku and *kyōka* are taught in Japan in Buddhist temples, Shinto shrines, and elsewhere. But how far the Japanese of today are removed from the artistic New Year's wishes of the Kansei, Kyōwa, and Bunka periods (1789–1818)! Today wealthy Japanese have a secretary prepare a list of persons who sent them New Year's wishes from the previous year as well as a list of newly made friends. Somebody is sent to the post office to buy a few hundred printed post cards. The post cards have no pictures as the old surimono had, but a lottery number instead. Thus the specially designed picture by an artist or a personally written poem have been replaced by a lottery number from which the recipient, if he is lucky, can win a few postage stamps. This is the trend of the time—not

only in Japan but all over the world beautiful old customs are sacrificed for the sake of expediency.

In order to flourish, every kind of art needs a sounding board, in other words, appreciative admirers of the works of art. The art clubs were the sounding board of ukiyo-e, and especially of surimono art. The elite of the artistically interested middle class formed the *ren* and patronized the arts.

Two : DESCRIPTION OF THE GENRE

The Subjects of Surimono Designs

By far the greatest part of all surimono were those given with good wishes for the coming year during the first days of the New Year. According to the formerly used lunar calendar, the year commenced during the second half of February of the Western calendar. This is the time when white- and rose-coloured blossoms signal the coming spring in Japan. Therefore, on hundreds of surimono, plum blossoms form a part of the decoration; they are the Japanese messengers of spring.

The sequence of the Chinese-Japanese calendar year cycle is: rat, cow, tiger, rabbit, dragon, snake, horse, sheep, monkey, cock, dog, and wild boar. Eleven of these twelve animals were well known to the Japanese. Tigers did not live in Japan but in nearby Korea. The dragon was, from antiquity, a well-known animal in Japanese as well as in Chinese fables. But sheep were unknown in Japan until Europeans and Americans introduced them after Japan opened its ports. The Japanese must have taken over the sign of the sheep from the Chinese zodiac. Therefore although 1823, the great year of surimono competitions, was the year of the sheep, one finds comparatively few surimono picturing sheep. Some show sheep, others goats. Rats were found in most Japanese homes in the nineteenth century. To the Japanese they are not as repugnant as to Americans and Europeans. The rat is the first of the twelve zodiac animals; it is natural that this animal is beautifully shown on hundreds of surimono.

Not only those animals of the zodiac cycle but also fish, lobsters, birds, butter-flies, turtles, and so forth take the third place among the objects of surimono designs. The first place is occupied by portraits of beautiful women and the second by still-life pictures. After these come men (actors, heroes, courtiers of legend and history), popular folk scenes, and landscapes. Japan's Seven Gods of Fortune and the *takara-bune* (treasure-ship) appear often, due to the fact that the purpose of the surimono was to wish people good luck.

Still-life painting found its widest, almost its sole application on the surimono during that time. All objects that played a role in the comfortable lives of Japanese art lovers at the beginning of the nineteenth century can be found among the subjects of still-life surimono accompanied by suitable poems; e.g., calligraphic samples, tea ceremony utensils, musical instruments, fans, masks, bows and arrows, coats of armour, dolls, books, playing cards, shells, and kitchen utensils. Approximately 20 percent of all surimono show still life. Scenes of everyday life, as well as anything the donor and the recipient may have experienced, planned together, or found especially interesting in the course of the last year was represented on the surimono.

Surimono are more than coloured woodblock printed pictures. The inserted poems were, to the donors and recipients, just as important if not more important than the illustrations. But few poems were written by renowned poets. The majority of them were by persons of entirely different professions even though they were interested and, to a certain degree, educated in "things literary." Therefore, the poems are only of secondary interest to the collector today. It has already been said that the pictures and poems were often only loosely connected and sometimes seem to have no recognizable connection whatsoever. Moreover, the poems were often quite banal; at least they have that effect in translation. Those poems may have been meaningful among friends who could allude to some common experience; but today the charm of such allusions cannot be revived and only the pictures and not the poems can be fully appreciated.

Except for a few highly talented experts such as Professor Wilhelm Gundert, almost no one has succeeded in translating Japanese poems into German with such skill and intuition that one can perceive not only the sense, but also the approximate form of the Japanese original. The author supposes that translations into English

also cannot transfer the sense, charm, and tone of the Japanese poems to full satisfaction. French and especially Italian may be better idioms for securing an effect similar to the Japanese original.

The Woodblock Printing Technique

Woodblock printing plates were carved. The master carver *(kashirabori)* carved the most difficult parts himself, i.e., the face, hair, hands, and feet of the figures; the assistants and apprentices carved the remaining parts. Everything was executed with precision according to the design and the greatly detailed instructions of the designing artist. Carving printing plates of wood was nothing new to Japanese carvers, because for centuries they had carved Chinese and Japanese characters for books.

Carving pictures, human faces, etc., was easier than carving characters. First the figures and forms were outlined on the first printing plate, and ten to twenty copies were made. Then the painter decided on the colours. If they were *ōban* ukiyo-e, the censor's stamp appeared on the printing plate, which only showed black outlines. However, surimono which were privately commissioned and given to friends did not have to pass this censorship. As soon as the printing plate with outlines was finished and the painters had decided on the colours, the carvers cut a separate printing plate for each colour. Then the paint was applied to the plate with a brush, and finally the paper was placed on the plate and rubbed with a brush or pad made of bamboo sheath—the so-called *baren*.

The beauty of each print depended upon the skill of the person who rubbed the paper on the printing plate; it required a very sensitive touch. It was not possible to make more than 200 copies at the very most. The number of the printed surimono did not have to be large, since they were commissioned by art-conscious citizens from their artist friends and distributed as presents only to a small circle of close acquaintances. In old Edo two, three, or more citizens got together and distributed the same picture. At any rate, the number of *ōban* ukiyo-e, which as mentioned were ordered by publishers and sold to everyone, was much greater than the number of surimono privately distributed. Consequently, collectors al-

ways discover surprisingly few copies of their own surimono in other collections.

A very good quality of thick paper called *hōsho* was used. The surimono size varied; after the year 1800 it was normally 20×18 cm. (7¾×7 in.), but there are many smaller surimono in existence, especially from the eighteeth century. The 20×18 size is called *shikishiban*. Such a small size necessitated art miniatures at which the Japanese are especially gifted. The thickness of the *hōsho* paper made good blind printing (gaufrage) possible, which was often used on surimono for producing special ornamental effects.

Not only beautiful colours and better paper, but also more luxurious printing distinguished the surimono from other ukiyo-e pictures. Mica backgrounds, gold, silver, and copper dust—particularly the blind-printing technique and everything that the woodblock carver and printers had learned in the course of the years— were lavishly applied in the making of surimono. Costs were of no consequence here. When, at the end of the nineteenth century the Japanese multicoloured prints *(nishiki-e)* became known in France, one admired among other things the marvelously precise fittings (registers) which were achieved by simple means. No colour fields spilled over into the neighbouring areas of colour.

The painters of ukiyo-e used as their colours blue, four kinds of red, five kinds of yellow, lilac-blue, white, black, yellowish brown (the colour of the persimmon fruit), grass green, spice brown, and orange. Blue was made from the leaves of the indigo plant which thrives in Awa on Shikoku. The different shades of red are crimson *(beni)*, Chinese vermilion *(shu)*, Indian red, or red oxide of iron, *(benigara)*, and minium *(tan)*. Crimson was made from the juice of safflower petals, vermilion from sulphuretted mercury, Indian red was made from burnt green vitriol, and minium from lead oxide. There were also five shades of yellow *(kuchinashi, kihada, shiō, sekiō, and ukon)*, some of which were taken from plant substances like tree bark and roots, and some from mineral substances such as sulphur and arsenic. White *(gofun)* was either lead white or pulverized oyster shells. Lilac *(sumire)* was extracted from the *tsuyu-kusa (Commelina communis)*. Black was the colour of Chinese ink with glossy additives. The persimmon colour was a mixture of crimson and *sekiō* or Indian red and a little black *(sumi)*. *Chōji-iro* (spice-brown) was another mixture of *sekiō* and vermilion. Green *(kusa-iro,* meaning grass green or dark green) was made by mixing *sekiō* and the

said lilac. Orange was made by mixing *zumi,* a yellow pigment from a tree bark, with crimson. Of course the nineteenth-century pigments were probably different from those used in the eighteenth century, and even Osaka pigments differed from those in Edo. The Japanese used hues made mostly from plants and a few of metallic composition, until Japan opened its harbours to foreign trade (1859). Colours made from tar were introduced from Europe, but they did not lend themselves well to ukiyo-e.

Painting and Poetry

At the turn of the eighteenth century customers ordered more and more pictures without the usual numbers of long and short months but with poems (generally *kyōka*) which they themselves had composed. Surimono pictures were often the product of a fine collaboration between professional artists and talented lay customers. When the eighteenth century neared its end, poems replaced the numbers of calendar months but the paper, colours, and technique of printing remained the same as formerly used for calendar prints.

The standard-sized surimono was popular for those printed in Edo (Tokyo). The surimono printed in Osaka were huge in size as the number of club members who immortalized themselves with their poems on them was also very high. On the surimono of Edo, for example, two or occasionally four poems never disturbed the beautiful impression which the pictures made. Fifty or more poems, however, with the names of club member "poets" take up the greater part of the surimono of Osaka so that the picture is limited in size and thus of secondary importance.

Poems on Surimono

It has been mentioned already that the poems on surimono are only of secondary interest to the foreign collector today. About 150 years ago, however, the poems were just as important as the picture. The men who wrote the lines were not actually poets; most were laymen schooled in literary clubs—merchants, shop-owners, and the like, while the surimono pictures were by great artists.

The poems—*kyōka* or sometimes haiku—were limited to 31 or 17 syllables. Today we do not know what feelings the giver and receiver had in common or what they had experienced together. Consequently, no matter how we try, we probably will never quite understand the full meaning and nuance that lie behind most of the poems. Besides, it is difficult to translate the lines into European languages so that the grace of the original poem can be felt.

Poems were written alongside or above surimono pictures. Nearly all of them were *kyōka*. *Kyōka*, or comic poems, are of the same form as tanka (poems with 31 syllables) but their nature is quite different. Tanka are formal; *kyōka* are only plays on words. To understand these *kyōka* one must be familiar with the customs and slang of the period just before and after 1800 in Japan. The poems were made to make men laugh, or to satirize by using funny or figured words.

1. A picture painted by Sadakage (Plate 20) shows a luxuriously dressed *oiran* (courtesan). She holds a brush between her lips and a scroll of writing paper appears in her left hand. With her right hand she dips an ink stick into water.

Ehangiri	Her first letter this year
Hana no ushiro o	Flowers decorate the paper
Misete kaku	Casting characters
Chirashi moji naru	Negligently.
Kari no hatsu fumi	Then she turns away to the flowers behind.

The following are descriptions of surimono (not shown) and their poems.

2. A different painting by Sadakage taken from an illustrated series on Yoshiwara shows a beautifully dressed girl. A candle burns on a tall metal candlestick.

Uguisu no	The nightingale sings
Hatsune no toko no	Love whispers in bed
Shikizome o	For the first time this year.
Ume to yanagi no	He, beautiful like a willow
Midori kurenai	She, delicate like plum blossoms.

3. A surimono by Hokkei pictures a young lady with poems on cards in front of her. She is wrapped in thought. Apparently the accompanying poem has no relation to the picture.

Umegae no	The nightingale sings
Hoshi no hayashi ni	Beautifully day by day in the woods
Najimi yoku	A nightingale's sound
Tsukihi o utau	She sings her song in spring
Uguisu no koe	For plum blossoms and stars.

4. In another surimono by Hokkei a beautifully painted carp swims.

Senkin no	A thousand golden coins
Haru no shirushi wa	Be worth in spring.
Koban hodo	Like groves on coins
Yoko ni suji o zo	Hazy mist
Hiku haru-gasumi	Lies across the country.

5. In a painting by Yashima Gakutei, a girl from Satsuma is pictured. She says good-bye to her old parents who squat in front of a kettle in their wretched hut. Probably the girl has sold herself to a brothel to help her parents who are in debt.

Harukaze no	Though the name says
Fuku to yū na mo	Spring winds blow
Kōbashiku	Yet cautiously
. . . takaki ni	Up to the heights
Kaoru ume no ka	The scent of plum blossoms does rise.

6. A surimono by Keisai Eisen depicts two white rats elegantly dressed as courtiers. They are pulling young pine saplings out of the ground. This is what the Japanese did on the first day of the year of the rat. They called it *ne no hi asobi* (day-of-the-rat playing).

Ne no hi suru	First day of the rat
Nobe ni komatsu no	To pull pine saplings.
Sukunaki wa	There are only a few.
Kasumi no sode ya	What may have hidden them?
Hiki kakushi keri	A sleeve of mist and haze.

7. A picture by Shinsai portrays a singing dancer and drummer who went from door to door during the New Year season expecting small presents. Saizō is the

partner in a *manzai* play (a Japanese comic drama form with two principal characters).

Ume warau	Attracted by plums
Kado o shirube ni	Blossoming at the gate
Uguisu no	Tatara Saizō
Saezuri te yoki	Is used to playing
Tatara Saizō	Accompanied by nightingales.

8. A surimono by Shinsai recalls the legendary land of Yamato, where two ladies stand on the bridge called Utatane no Hashi (the Bridge of Semi-slumber). One lady has a baby strapped to her back; the other bends down to touch a tree twig.

Aoyagi no	On the day when the green
Ito asobu hi wa	Branches of the weeping willow
Yume mo mata	Play with the winds
Kurikaeshi min	Dreams come back
Utatane no hashi	Here to the bridge of slumber.

9. In a different picture by Gakutei, a girl stands at the entrance gate to Yoshiwara, the gay and lively quarters in Edo.

Yozakura ni	Cherry blossoms in the night
Edo-machi o dete	Walking from Edo
Kyō-machi e	Towards Kyoto city.
Yuku ya ekiro no	The stations along the way
Komageta no oto	The noise of tripping wooden clogs.

Calendar Prints

The precursors of the surimono were the so-called illustrated calendar prints *(e-goyomi)*. To print calendars was the privilege of only very few publishers *(koyomi-ya)*. But for everyday life it was sufficient to know which months of that particular year were short or long (29 or 30 days). Therefore, pictures were printed in which the numbers of the long or short months were hidden.

Calendars were the most natural gifts for the New Year's celebration. Thus it
came about that in the Meiwa period (1764–72) people began to exchange gaily
coloured woodblock prints containing the hidden numbers of the month. Since
they were distributed to friends and generally not sold, one can consider such
abbreviated and illustrated calendars to be surimono, even though they are usually
much smaller than the normal size of the later surimono. Besides being called *e-goyomi* these calendar sheets were also named *ryaku-reki*, i.e., abbreviated calendars.

Both Suzuki Harunobu (chief period of creativity 1765–70) and his friend
Kyosen, the leader of the Kiku Ren, designed calendar prints, although the author
unfortunately has not yet seen illustrated calendars of these two artists. Certainly
they are very scarce today. It is well known that Suzuki Harunobu was the first
artist who designed pictures for the newly developed or rather perfected, multi-coloured woodblock prints. Three or five and soon up to eleven colours were
used; for each colour a printing plate was carved.

We know that calendars have been printed before Harunobu, as several of them
are preserved in British and American museums, but it would be too farfetched
here if we tried to establish the relations of such old calendars with the surimono
designed and printed for private citizens and distributed by them to their personal
friends. It is a known fact that Japanese collectors around 1800 pasted *koyomi* in
their surimono albums. But somewhere a boundary should be established; a suggestion might be to include illustrated calendars *(e-goyomi)* in surimono, but to
exclude those without illustration *(koyomi)*.

Signs and Seals

The majority of surimono bear the signature of the artist-painter. Only about ten
percent of all surimono are not signed, although the names of the lay poets are
never missing. Rarely one finds the seal of the engraver who carved the wooden
printing plate or likewise the seal of the printer. More often, the name of the art
club was imprinted. Censors' or publishers' stamps are not found on them since
surimono were privately printed. A few surimono, however, were later copied
and sold by publishers and therefore bear the stamp of a censor. These are exceptions.

The character *kō* (考), whose meaning was for some time disputed, designates the person who gave the inspiration for the picture; it was frequently the sign of the patron himself. We may assume that many patrons came to the artists with their own designs and sketches, and that this was given recognition by the sign *kō* in front of the name. In the majority of surimono the painter's signature is accompanied by the character *ga* (画), meaning designer, and sometimes by *gakō*, a combination of both characters meaning designer and creator. In addition, the character *aratame* (改), meaning repeated or innovated, sometimes appeared with the signature; often pupils or the master himself designed the same picture, adding small changes. Some surimono business transactions were indicated by the *ōju* (応需), meaning drawn by commission.

Three : THE ARTISTS

The Life of a Japanese Artist

If a boy in Japan showed great talent for drawing pictures and if the father agreed to his son becoming a painter, the son studied with a painter as apprentice. The master artists in most cases insisted that their pupils first learn to paint in exactly the same style as the master. Only after several years of service as an apprentice and later as assistant was the pupil allowed to make certain alterations or innovations of his own. After many years a pupil could become independent by leaving the school or he could remain in it and use his own name.

There were many schools of painting: Hishikawa school (founder, Moronobu), Kaigetsudō school (Andō Kaigetsudō), Nishikawa school (Sukenobu Nishikawa), Kitagawa school (Utamaro), Nishimura/Suzuki school (Harunobu), Chōbunsai school (Eishi), Kitao school (Shigemasa and Masanobu), Kikukawa school (Eizan and Eisen), Utagawa school (Toyoharu, Toyokuni, Toyohiro, Kunisada, Kuniyoshi, and Hiroshige), Katsushika school (Hokusai, Hokkei, Gakutei, Shinsai, Shigenobu, Hokuma), Torii school (most famous members: Kiyonobu and Kiyonaga), Miyagawa/Katsukawa school (members: Shunshō, Shunkō, Shun'ei, Shunchō, and Shuntei), and others as well. But only the Torii, Miyagawa, and Utagawa schools lasted for more than two generations after their founding. Such famous masters as Harunobu, Utamaro, and Eishi did not have much luck with their pupils. **29**

Either the talent of the pupils was not sufficient, or the master was a splendid painter whose pedagogic abilities did not suffice.

Artists gladly composed, designed, and decided the colouring for surimono. They offered their services because it provided them with a good source of income. This was, unfortunately, not the case when producing the large ukiyo-e placed on the market by publishers and dealers. Publishers everywhere had one thing in common, the desire to make a reasonable profit. The Japanese publisher was no exception. He had to pay the woodcarver, the printer, and the artist. The most beautifully coloured woodblock prints were sold for practically nothing by publishers in their stores or by dealers who also wanted their share of the profit. Thus, little of the meagre profit remained for the poor artist. Some of the artists, Kunisada for example, had other sources of income. Most of them were poor. Imagine how the ingenious Hokusai had to worry about money matters throughout his entire life.

How then did these artists augment their incomes? Perhaps by illustrating books. They did that, to be sure, but for little pay. Publishers marketed the books which from ancient times until very recently have been ridiculously cheap in Japan. The artist saw only two possibilities of improving his finances: by painting erotic pictures or by producing surimono. In both cases, buyers spent their money freely. The surimono artist and frequently the painter of erotic pictures earned a good living by avoiding middlemen and selling their products directly to customers and patrons.

Turning to the individual artists, we do not extend our investigations to the precursors of surimono art. It was not until the Meiwa (1764–72) and An'ei (1772–81) periods that we find the earliest artists who did calendar illustrations or designed actual surimono. It was then that the multicoloured *kubarimono* (an article which was distributed free as a gift) came into existence.

The "Golden Age"

Japanese historians refer to the Temmei, Kansei, and Kyōwa periods (1781–1804) as the "Golden Age" of ukiyo-e. We may say that the *ōban* ukiyo-e art reached the end of its popularity around 1800. This epoch is represented by such famous

artists as Kiyonaga, Utamaro, Eishi, Chōki, Shunshō, Shumman, Toyokuni,

Toyohiro, and a few others. Except for the latter three, the great painters of the
Golden Age did not produce very many surimono. The surimono art reached its
highest summit later, namely in the first quarter of the new century. Almost all
painters living between 1800 and 1830, including some of those above, devoted
much of their time and the best and most careful part of their art during this period
to designing surimono. Hokusai, his pupils including Hokkei, Gakutei, Shinsai,
Hokuma, and others, the Utagawa school, especially Kunisada, Kuniyoshi, and
their pupils, Eizan, Eisen, and Hiroshige—all were kept busy fulfilling the regular
demand for surimono from art-club members.

The two years, 1804 and 1823, produced an abundance of beautiful surimono.
The first year of a 60-year cycle was 1804; it was the year of the rat *(ne no toshi)*.
Around this time, Hokusai produced the most beautiful of all his surimono. In
1823, the year of the sheep *(hitsuji no toshi),* great competition was held between
several artist clubs. Everyone attempted to produce beautiful and ingenious suri-
mono as a New Year's greeting and the Society of the Flower Hats (Hanagasa Ren)
distinguished itself. But the time when enthusiasm for surimono was to fade was
not far away.

SUZUKI HARUNOBU (*ca.* 1724–70)

In this work which is limited to surimono, we need not say much about the great
Suzuki Harunobu. The only thing worth mentioning is that he illustrated calendar
prints, i.e., multicoloured and small printed pictures on which the somewhat hid-
den long (30 days) and short (29 days) months could be read. Calendar illus-
trations were the precursors of surimono art.

Many books and essays have been written about Harunobu so that we can now
presuppose general knowledge of him, and not much needs to be added. One
should, however, by no means give him sole credit for the "invention" of the
multicoloured printing process *(nishiki-e)* in the year 1765. Only the woodblock
carvers and printers of that time could have invented it. Kyokutei Bakin names a
certain engraver, Kinroku, as the inventor who, in collaboration with the printer,
developed this technique. One may assume this to be true. The difficulty in multi-
coloured printing lies in designing a process by which no colour spills over into

the neighbouring colour fields; in other words, exact fittings had to be developed. This is a concern for both the printer and carver of a woodblock print. It is possible, however, that Harunobu and his friend Kyosen inspired multicoloured printing and perhaps even gave good advice to the carver and printer, but Harunobu the painter was not the "inventor" of the technique.

After this technique had been perfected, large single-colour woodblock prints *(ōban)* which had cost only 24 *mon* (small monetary unit in use in the Tokugawa period) were no longer made. Now, Harunobu's medium-sized pictures *(chūban)* cost 160 *mon* each.

In the surimono medium, Harunobu illustrated calendar sheets, i.e., small printed pictures containing somewhat hidden numbers for the months.

Although we know that Harunobu used models for his beautiful female figures —their names were O-Sen, O-Fuji, and O-Sode—his delicate and elegant figures are effusions of his dreams; in his erotic pictures they appear incredulously innocent. When Harunobu died five years later, the *nishiki-e* technique had already been perfected and his fame was assured. When he died, prematurely, he left no pupil worthy of mention. Harushige, who occasionally called himself "*nidaime* Harunobu" (the second Harunobu), was actually the well-known artist Shiba Kōkan. Though not a pupil of Harunobu, he later confessed that he forged Harunobu's signature on his own woodblock prints after Harunobu's death.

KIKURENSHA KYOSEN (d. 1777)

It was Kyosen who inspired Harunobu. Kyosen was an intellectual leader of his time. We know many names of the members of the art club Kyosen Renjū which was named after him. No other name appears on pictures as often as his; in most cases with the addition "designer." Without a doubt, Kyosen himself made drawings or sketches, and gave Harunobu inspiration and advice. Since the clubs staged competitions with one another, it is understandable that Kyosen had his ideas executed by the best artist of his time.

We may safely assume that Kyosen sometimes placed his own signature on Harunobu's pictures. Considering the close collaboration of the two artists, this should not be interpreted to Kyosen's discredit. Perhaps it was necessitated by the competition with other clubs, or there may have been some other plausible reason.

His sign as designer and creator can be found most frequently on prints which bear

the seal of the Kikurensha.

Allegedly, Kyosen himself carved printing plates at the time of the first *nishiki-e*. If this is true then he, rather than the great painter Harunobu, should be credited with having contributed significantly to the development of the multicoloured printing technique. Kyosen belonged to the samurai class and had the considerable annual income of 1600 *koku* of rice (one *koku* equals roughly five bushels) as a *hatamoto*, and was a high official (librarian) in the service of the Tokugawa Bakufu.

ISODA KORYŪSAI (worked mid-1760's to 1780's)

Koryūsai studied painting under Nishimura Shigenaga, who had also been Harunobu's teacher. Koryūsai was a samurai who, like Harunobu, painted *bijin-e*. He followed Harunobu's style so closely that at first glance the viewer thinks he is looking at work produced by the great master himself. Then it becomes evident that Koryūsai's women are not quite so innocently pure as Harunobu's dream-figures. Besides, his colours and contours are somewhat thicker. His women look sturdier and more intelligent, so the viewer responds more personally to them.

Koryūsai did not design *yakusha-e* (prints of actors) because he had no use for the theatre people of his time. He preferred to paint young girls from Edo pleasure quarters. One of his specialties was *hashira-e* (pillar pictures—long, narrow pictures which were pasted on Japanese house posts for decoration).

Most representative artist of the An'ei period (1772–81) and the years between Harunobu and Kiyonaga, Koryūsai was highly respected by his contemporaries and his ukiyo-e are still very expensive today. The rank of a *hokkyō* was granted to him. After he received this honour, he apparently made only hand-painted works and no longer ukiyo-e. Edward F. Strange, noted colour-print expert of the Victoria and Albert Museum, held the opinion that Koryūsai was the first Japanese artist who designed surimono.

KATSUKAWA SHUNSHŌ (1726–92)

A surimono artist who belonged to the Katsukawa school, Shunshō is known to have had at least 17 pupils. Several of them were among the best artists of the so-called Golden Age of ukiyo-e art. Shunshō excelled particularly in hand-painted

portraits and woodblock prints of beautiful women or actors. His portraits of battle scenes *(musha-e)* are also very highly considered. Shunshō preferred to design narrow pictures *(hoso-e)*. Without a doubt, Shunshō ranks among the very best ukiyo-e artists.

KATSUKAWA SHUNCHŌ (worked late 1770's to late 1790's)

Perhaps the best among Shunshō's pupils is Shunchō. He designed almost exclusively female beauties in the manner of Kiyonaga. Shunchō had a preference for painting nude or semi-nude women, a preference which he shared with several artists of this Golden Age. Around 1796 Shunchō stopped painting, after which he devoted himself entirely to writing comic poems. He used models, for instance, Takashima no O-Hisa, whom Utamaro also portrayed. However, Shunchō did not portray idealized beauties but more natural and realistic ones. He used richer colours, and was an outstanding painter of feminine beauty.

UTAGAWA TOYOHARU (1735–1814)

Even more than as an artist, Toyoharu deserves our attention as a significant personality in Japanese art history. He was the first to design ukiyo-e depicting landscapes and interiors of houses after the Dutch models. The ukiyo-e school he founded remained in existence longer than any other. It produced Japan's most famous artists of that time. Toyokuni and Toyohiro were his pupils. Toyoharu painted many themes, including lovely women on *kakemono-e* (hanging scroll picture). Toyoharu's hand-painted pictures are better than his prints, but he designed a good number of first-class surimono. He also tried to paint theatre programmes and posters; however, he committed the horrible blunder of forgetting in an important programme the name of the chief actor. This was reason enough to dismiss him.

Fifteen years later prior to Toyoharu's death, Shōgun Yoshimune had permitted the import of Chinese books, and many pictures had come to Japan which showed the Western technique of painting. Already long before Toyoharu feeble attempts had been made to paint in the Western style in Japan, but Toyoharu thoroughly studied the alien manner of painting. He copied and studied until he was well able to design scenes of the city of Edo in the new fashion. He also succeeded in de-

signing with European perspective the interiors of houses and theatre halls of
Yoshiwara. Such pictures are called *uki-e.*

Toyoharu became the precursor of the landscapists Andō Hiroshige and Uta-
gawa Kuniyoshi. Anyone who speaks about Japanese landscapes must mention
Toyoharu.

Toyoharu studied in Kyoto with a master of the Kanō school but he went to
Edo in 1764 prior to the beginning of the Meiwa period. Only a few of his *chūban*
ukiyo-e of beautiful women or actors are known to exist. The serenity of his paint-
ings corresponds with his background. He became an educator, teacher, and found-
er of the great Utagawa school.

KITAO SHIGEMASA (1738–1820)

Shigemasa, the founder of the Kitao school, saw many illustrated books in his
father's bookstore and thus formed his artistic taste. He painted up to the time of
his death at 82, and left behind a great number of pictures—the first of which still
belonged to the style of old *benizuri-e* (crimson red pictures). During the Meiwa
period, Shigemasa began to display greater independence in his art; during the
An'ei and Temmei periods (1772–89), he stood among the greatest of his time.
In 1770 he painted together with Shunshō the famous picture album *Bijin Awase*
(A Collection of Beautiful Women). Throughout his life he painted beautiful
women, occasionally *uki-e,* but not as many as Toyoharu. Shigemasa also illus-
trated many *kibyōshi* (cheap illustrated novelettes in yellow bindings) and a few
e-hon (picture books). His erotic pictures are very good. He knew how to endow
his women with an abundance of sex appeal.

The writer has not yet seen a surimono designed by Shigemasa, but they have
been recorded, for instance in the Buckingham catalogue of the Art Institute of
Chicago; and The Fogg Museum possesses nine Shigemasa surimono. His work
had considerable influence on several other surimono designers.

KATSUKAWA SHUNKŌ (1743–1812)

Having lost all use of his right arm at the age of about 45, Shunkō painted with
his left hand. He portrayed many wrestlers and actors, but only a few beautiful
women or warriors. He painted portraits showing chest, shoulders, and head called

okubi-e; however, some of his *okubi-e* did not extend to the chest and are visible from only the neck upward with the face filling almost the entire picture. Utamaro, too, painted his pretty young women occasionally in this fashion. Shunkō, as an artist, was by no means inferior to Shun'ei but he was less ostentatious. Besides, Shunkō stood more in the shadow of their common teacher, Shunshō.

KUBO SHUMMAN (1757–1820)

Shumman was a pupil of Inō Nahiko (1723–82) and of Kitao Shigemasa. He chose a different sign for the "Shum" of his name in order to make it known to everyone that he did not belong to the Katsukawa school. He used many pseudonyms *(gō)* on surimono, and as a writer frequently signed as Shōsadō. He was an expert at painting beautiful women; many of his hand-painted pictures are still preserved. He designed many still lifes on surimono, as well as other pictures of beauties, animals, landscapes, and scenes of common people. Although he had been taught by Kitao Shigemasa, his pictures are more in the style of Kiyonaga. Like Eishi, Shumman did not like the colour red but preferred blue, green, and yellow.

Shumman was a versatile man. He enjoyed popularity and cultivated friendship with men of letters and artists. Although he was left-handed he had a fine manual dexterity. He painted well, was a great master of shell craft, and was skilled in metal engraving. His eldest son and grandson were printers, and Shumman liked to help them.

The most famous of Shumman's large-sized works are his six Tamagawa prints, beautiful figures with landscape backgrounds. He designed many surimono, still lifes, beautiful ladies, animals, and landscapes. All his friends and acquaintances asked him to design surimono for them. His family connection with a printing shop may also be a reason why he received so many orders for surimono.

TORII KIYONAGA (1752–1815)

Kiyonaga entered the Torii school in 1765 and studied under Torii Kiyomitsu (1735–85). When the latter died, Kiyonaga became the head of the Torii school, although unwillingly, for he specialized in *bijin-e* (pictures of beautiful women), whereas he had to paint *yakusha-e* (pictures of actors), as head of the Torii family.

The Toriis had been for several generations the commissioned artists for three great theatres in Edo (Nakamura-za, Morita-za, and Ichimura-za).

In the year 1767 when Kiyonaga painted his first pictures, the multicoloured printing process had just begun—and with it the fame of Harunobu. Koryūsai, Shunshō, and even Kiyomitsu imitated Harunobu. Naturally the young Kiyonaga could not exclude himself, but when Shunshō went his own way, Kiyonaga followed Shunshō's example, at least as far as his portraits of actors were concerned.

Much of Kiyonaga's time, however, was devoted to the illustration of *kibyōshi*. He illustrated 128 of them. Kiyonaga reached the height of his career in the 1780's. Whether his famous portraits of beautiful women have been surpassed by Utamaro or not is a matter of taste. Kiyonaga's portraits have small faces, round eyes, and small, elongated chins; they are elegant, gay, and natural; their bodies are well proportioned. Contours and choice of colour are magnificent.

In the 1790's Kiyonaga noticed that the common taste of the people turned more and more to elaborately coloured paintings by Utamaro, in which the backgrounds were adorned with glitter dust and the like, but he continued to paint in his own noble style. Later, however, he gave up painting. He did not design very many surimono; for this reason his surimono are extremely rare. The great collection of the Fogg Museum includes only a single Kiyonaga surimono. Kiyonaga's last duty was to educate Kiyomitsu's grandson who, as Kiyonaga had planned, later assumed the name Kiyomitsu II and took over the leadership of the Torii school.

KITAGAWA UTAMARO (1754–1806)

Utamaro, like Kiyonaga, ought to be only a marginal figure in this work which limits itself to the discussion of surimono. In the book *Utamaro,* which was published in 1907, Dr. Julius Kurth enumerates 29 surimono, 18 of which Dr. Kurth himself had not seen. Perhaps at the most, ten of these prints are genuine surimono. As for the others, either the size is too large or too small, or the subject is not suitable for a surimono. In Dr. Kurth's book not a single surimono is reproduced; neither are there any Utamaro surimono in the catalogues of older collections (by Mosle, Solf, Davison-Ficke, Straus-Negbaur, etc.). The Fogg Museum possesses six Utamaro surimono. This proves that he designed surimono but almost all of them have long been in the hands of his admirers. Utamaro remains the most

famous of all Japanese painters of women. He had many pupils who shared his celebrations and his gay life, but apparently he was not a successful teacher, for not one of his pupils made himself known as an artist. The Kitagawa school existed after Utamaro's death for barely a generation.

EISHŌSAI CHŌKI (worked 1760's to 1810)

Like Utamaro, Chōki was a pupil of Toriyama Sekien (1711–88), a book illustrator of the Kanō school. Both Chōki and Utamaro did not follow the ways of their master but developed their own independent style. Chōki does not stand on the high level of Utamaro, Eishi, and Kiyonaga, but he ranks as high as Shunchō. Chōki was more independent, keeping his own individual style while Shunchō was much influenced by Kiyonaga.

Chōki made portraits of actors. He also illustrated *kibyōshi* books but far more than anything else his pictures of beautiful women are admired. It is difficult to define why his females are so attractive, but it is a fact that they are beautiful and different from the beauties by all other artists.

Chōki produced only a comparatively small number of *ōban* ukiyo-e; surimono by Chōki are extremely rare. The world's largest surimono collection at the Fogg Museum has not a single one by him.

Historians do not know much about Chōki's life. It is, however, certain that already before 1763 he had illustrated certain *kyōka-bon* (collections of comic poems). When young, he called himself "Shikō." He adopted the name Chōki not earlier than 1788. After 1796 he again signed Shikō, and after 1801 changed back once more to Chōki.

HOSODA CHŌBUNSAI EISHI (1756–1829)

Eishi, the founder of the Hosoda school, was a samurai of high rank; in other words, a *hatamoto* in the service of the tenth Tokugawa shōgun. He was the first son of a noble family. While still a *hatamoto* he designed *nishiki-e*. When he turned 34, he retired on the fifth day of the eighth month in the year 1789 (as recorded), left his position to another member of the family, and became a professional illustrator of ukiyo-e. As was usual, he changed his first name repeatedly, but he kept the name Eishi which the shōgun had bestowed on him. He derived the name

Chōbunsai from a certain teacher. Together with Utamaro and Kiyonada, Eishi

belongs among the best painters of women during the Golden Age of ukiyo-e art.

Eishi's style always remained noble and in good taste; he executed his subjects in a beautiful, clean manner, no matter whether he portrayed ladies or *oiran*. While avoiding harsh colours, he used for his multicoloured prints black, indigo, lilac, yellow, green, grey, and less frequently, red. Eishi's pictures are serene. In this respect, even his erotic pictures, as well as those of his pupils, Chōkōsai Eishō and Shikyūsai Eiri, are worth special mention. They were great artists of *okubi-e* which showed beautiful girls' faces on glitter-dust backgrounds. Other pupils were Eisui and Eishin. Eishi himself portrayed the greatest beauty in his series *Fūryū Go-sekku*. These *bijin-e* on a yellow background show the five festivals of the Japanese year—festival of the New Year on January 1; doll festival on March 3; boy's festival on May 5; festival of the stars on July 7, and festival of the chrysanthemums on September 9.

The "Decadent Age"

The period in ukiyo-e art which followed is called the "Decadent Age" *(haitai jidai)*. Some of the most famous *ukiyo-e-shi* belong to this period and many masterpieces were created. Especially for surimono, one certainly cannot say that it was a decadent time; indeed surimono did flourish between the years 1800 and 1830.

Japanese scholars consider the Decadent Age as the time from Bunka 14 to Keiō 3 (1817–67). Hokusai produced his best landscape prints after 1830. Hokusai, Eisen, and Hiroshige lived well up to approximately the middle of this era; Kunisada and Kuniyoshi to the last quarter; and Eizan and Gakutei to the end. When Hokusai and Hiroshige's landscapes represent the all-time high points of landscape painting, we cannot help thinking that the word "decadent" leads us a bit astray. Of course, we are ready to admit that in the field of *bijin-e,* the masterpieces of Kiyonaga, Utamaro, Shunchō, Shunshō, and Eishi, who died in the previous period, have never been equaled.

KATSUSHIKA HOKUSAI (1760–1849)

Hokusai designed a great number of beautiful surimono, and his pupils Hokkei, Shinsai, Hokuma, Shigenobu, and Hokkei's pupil Gakutei, designed more surimono than their master or any other artists.

Hokusai's father, Kawamura Hachiemon, died at an early age. Tokitarō, as Hokusai was called as a child, was adopted at the age of four or five years by Nakajima Ise, a craftsman in metallic mirrors who named the child Nakajima Tetsuzō. At the age of 14 or 15 years he was sent into apprenticeship with a book dealer, then with a woodblock carver who carved plates for *nishiki-e*. Here the boy worked for several years and learned much that was beneficial for his later career. He also met the then very popular painter Katsukawa Shunshō, one of his master's customers, who accepted Hokusai as his pupil in 1778. After only one year, Shunshō honoured his gifted pupil by awarding him the name Katsukawa Shunrō. For the next eight years Shunrō remained with his teacher, but then he craved further knowledge and experience. He tried his hand at painting in the style of the classical schools, Tosa and Kanō. This led to conflicts and finally to Hokusai's withdrawal from the Katsukawa school. Hokusai utilized the following years to continue his training with various masters and learned among other things, the art of copper engraving and the concepts of European perspective. During these difficult years he earned his living by illustrating books, and for a while he painted actors in Shunshō's manner and beautiful women in the style of Kiyonaga. From about 1793 to 1798 he used the name "Sōri." At that time he had already designed fine surimono.

After 1799 he called himself Hokusai. Throughout the rest of his long life, he kept this name, but he changed his surnames and signature over and over again (32 times, in fact). This could facilitate the dating of his works if one knew exactly when he used this or that signature. Unfortunately, Hokusai did not make it very easy for the historians. Even today, Japanese scholars are trying to solve this problem.

The period from 1799 to 1819 was perhaps Hokusai's most productive period. He now signed his works "Hokusai," "Iitsu," "Tatsumasa," or even "one who is crazy about painting." By now he was already famous among the people of Edo for his *kyōka-bon* and *e-hon*. The number of his surimono from this time is also

great. Towards 1820 he signed several surimono "Taito." In addition to these suri-mono, Hokusai created, at various times, programmes for theatre performances, banquets, and so forth, which are precious works of art today. According to Louis Gonse, these programme leaflets are the greatest which were ever created in this genre. Hokusai's *Views of Both Banks of the Sumida River* (1806) is a master-piece of this period. All of these pictures display the inexhaustible wealth of his ideas, his eye for the comic, and his power of representation.

His most famous work is the *Thirty-six Views of Mount Fuji* (1825–32), which was later expanded to 46 views. Other famous works are *The Eight Best-Known Waterfalls* and a series of ten paintings called *Poets of China and Japan*. The *Hundred Views of Mount Fuji* was not designed until 1834. *Representations of Childlike Love*, a work of two volumes, must be considered among his masterworks. The Atami Museum owns a collection of hand-painted portraits of beautiful women by Hokusai.

Hokusai also portrayed his women in a different manner compared with Uta-maro, Kiyonaga, etc. He captured them in a moment of unintentional movement and did not care much about beauty.

At the age of 68, Hokusai suffered a stroke and for some time was partially paralyzed. His third daughter nursed him through his illness, although he rudely called her "oi" (hey) and never addressed her by her name, so "Oi" became her nickname. According to Hokusai, a lemon cure helped him recover his health.

Hokusai was popular with the Japanese people, especially with the lower and middle classes. But for the elegant upper class he was not fine enough. He was immensely industrious and is supposed to have made 35,000 drawings and paint-ings. He illustrated at least 168 literary works and 487 volumes altogether. Yet in spite of his great industry and popularity, Hokusai never had money. He was a real Bohemian, negligent in his manner of dressing. He moved 93 times, some-times only to escape from his creditors. However, one of the reasons for his con-tinued poverty allegedly was a wayward grandson. Because of his pride, he never compromised on anything, although Japan is known to be a land of com-promises. He never submitted to anyone's influence and always painted just as he pleased. We might perhaps explain his temporary use of the Buddhist swastika *(manji)* as his signature or as a symbol of his religiousness or, better, superstition

accompanying his signature. He wished to live a long life so that he could continuously improve his art. Hokusai died at the age of 90.

KATSUKAWA SHUN'EI (*ca.* 1762–1819)

A pupil of Shunshō, Shun'ei designed ukiyo-e prints and also painted picture scrolls, theatre programmes, posters, and many narrow (6-inch wide) portraits of actors or wrestlers. He must have been a popular and sociable man, for he frequently collaborated with Utamaro, Toyokuni, Shunchō, and other artists. He loved the Kabuki theatre and Gidayū music and played the *samisen* (three-string instrument) well, but as a painter he did not attain the fame of his master, Shunshō. Shun'ei's pseudonym as an artist was Kutokusai; his well-reputed manner was called "Kutoku style."

KATSUKAWA SHUNTEI (1770–1820)

Shuntei, a pupil of Shun'ei, was active in all genres—*bijin-e, yakusha-e, musha-e,* and landscapes. He was also an illustrator of books. But not very many of his surimono have been preserved. He designed landscape pictures of Fukagawa and Shinagawa (districts in Edo) and also the *Eight Landscapes at Lake Biwa* with European perspective. Due to the liberal training which Shuntei received from his teacher Shun'ei, he was less constrained in his style than other painters of his time. Shuntei gave up painting prematurely because of illness.

UTAGAWA TOYOKUNI (1769–1825)

Toyokuni's father, Kurahashi, was a puppet carver who sent his son to be an apprentice of his good friend Toyoharu. Already at the age of 17, Toyokuni had illustrated *kibyōshi*. Although he was never very original, he gradually became an artist of the first rank. In the course of subsequent decades, Toyokuni imitated not only his teacher Toyoharu, but in his portraits of women he assimilated successively and without discrimination the styles of Shigemasa, Kiyonaga, Shumman, Eishi, Utamaro, and even Toyohiro. Furthermore, when portraying actors, he incorporated the mannerisms of Shunkō, Shun'ei, and Sharaku. But in spite of this apparent lack of originality, Toyokuni was a great artist.

In his series *Views of Actors in Roles,* which he painted between 1794 and 1796,

as well as his portraits of actors on plain backgrounds, he created masterpieces

which surpass even his models and are unique in their field.

In his time he was a truly fashionable painter. Publishers thronged to his gate and begged for Toyokuni's pictures. But he seldom complied with their wishes and preferred to devote the later years of his life to wine, women, and song. At the age of 46 he married a girl of barely 16 years who, after Toyokuni's death allegedly married his pupil, Toyoshige Ichiryūsai. This, however, has meanwhile been disputed. At any rate, for some reason within the Utagawa family, Toyoshige was temporarily made the head of the Utagawa school, and given the name Toyokuni II, an honour which Toyokuni's most famous pupil, Kunisada, had expected.

In the last years of his life, Toyokuni designed only the faces of his portraits and left the remaining parts to his many pupils. Among his students the most famous are Kunisada (Toyokuni III) and Kuniyoshi. Even when Toyokuni was still alive, Kunisada surpassed his teacher's fame. Toyokuni did not only paint beautiful women and actors as *Azuma nishiki-e* (multicoloured pictures printed in Edo), but illustrated picture books and the so-called yellow books. Among many other books Toyokuni illustrated *Sakura-Hime Zenden Akebono Zōshi* (Complete Legend of Princess Cherry Blossom: Dawn Book) by Santō Kyōden (1761–1816).

With his large number of pupils, Toyokuni greatly enhanced the fame of the school which Toyoharu had founded. Yet in 1818 the otherwise lucky Toyokuni met with a great misfortune. He illustrated a book about Hideyoshi, the famous enemy and predecessor of the Tokugawa family. Consequently he ended up in court. Utamaro, who was subjected to a similar lawsuit, told the judges that Shun'ei, Shuntei, and Toyokuni had likewise illustrated such books. Thus they were all sentenced to 50 days in the stocks. Toyokuni died at the age of 57.

UTAGAWA TOYOHIRO (1773–1828)

Utagawa Toyohiro was like a modest younger brother who was unable to rise to notable fame in the shadow of the great Toyokuni. In 1782 Toyohiro began to study under Toyoharu; his real name was Okajima Tōjirō; his *gō* was Ichiryūsai. During the 1790's Toyohiro himself began to teach. One of his later pupils, who owed much to him, was the greatest Japanese landscape artist, Andō Hiroshige.

As a landscape artist Toyohiro certainly surpassed Toyokuni; similarly, many people prefer the former's feminine portraits to the latter's, whose strength lay in painting actors. A substantial collection of Toyohiro's feminine portraits is owned by the Atami Museum.

One might feel sorry for Toyohiro because he did not have the gift of making himself popular, and therefore felt inferior throughout his life. Toyokuni always followed the popular taste and imitated Sharaku and his own close friend Utamaro when the two came into fashion. Toyohiro, however, remained true to himself. His landscapes combine *Yamato-e* (pictures with typically Japanese characteristics) with Western perspective.

Toyohiro began rather late (about 1800) to illustrate *kusazōshi* (collections of novelettes) and soon he, too, became a master in this field. Friends tried to improve Toyohiro's relationship with Toyokuni and finally succeeded in persuading the two, who had shared the same teacher and yet were so dissimilar in personality, to collaborate on a book of illustrations. As expected, Toyokuni's pictures were very forceful, while Toyohiro's contributions were delicate and gentle. However, Toyohiro designed three times as many surimono as Toyokuni and among them there are many of considerable beauty. Toyohiro died in 1828.

TEISAI HOKUMA (1771–1844)

Another of Hokusai's students, Hokuma, made colour prints *(hanga)*, designed surimono, and illustrated *kyōka* books. However, his best works are hand-painted pictures of beautiful women. In all other fields Hokuma is overshadowed by the greatness of his master.

RYŪRYŪKYO SHINSAI (worked *ca.* 1790–1820)

Shinsai occupies the second place among all surimono designers, if one considers the number of his surimono. Almost one half of his works is still life; approximately 20 percent are portraits of beautiful women. As a landscape painter he very closely followed the example of his teacher, Hokusai. The master honoured him with the name Shinsai, which Hokusai himself had used in his youth. After Hokusai, Eisen, and Kuniyoshi, Shinsai, together with Katsukawa Shuntei and Hokuju, can be considered among the prominent landscape painters of the European style

of that time. Especially praised among Shinsai's landscapes are the *Eight Views of Omi.* The most beautiful of his works is the surimono series *Kasen Awase,* which contains 36 very fine prints. The surimono of this series show ladies engaged in various occupations; they are set in beautiful landscapes. A shell is printed in the upper right-hand corner of each.

TOTOYA HOKKEI (1781–1850)

The most gifted among Hokusai's many pupils was Totoya (or Uoya) Hokkei. He was born as Tatsuyuki; his pseudonym was Aoien. He designed more surimono than any other artist. Common subjects to Hokkei were still life, beautiful women, animals, scenes of public life, and less often, actors or heroes. He was called Totoya (literally, "fish peddler") and frequently he himself signed in this way because, as a youth, he had worked at the fish trade. A great artist recognized by everyone, he was not ashamed of his modest origin. Hokkei designed practically no *hanga* (colour prints) in the customary *ōban* format, but only surimono and book illustrations. Totoya Hokkei equaled his master's skill so well that we can hardly distinguish his pictures from Hokusai's.

YASHIMA GAKUTEI (*ca.* 1786–1868)

Not really a pupil of Hokusai's, Gakutei became Hokkei's pupil and thus came into Hokusai's workshop. As "Horikawa-no-Tarō" he made himself a name among writers and was called "Kinzan," a *kyōka* poet. We do not know the exact dates of his birth and death; we only know that he painted some time during the first three decades of the nineteenth century. Gakutei illustrated books, designed a few landscapes of larger size, but otherwise did only surimono.

Gakutei was the son of a samurai by the name of Hirata, who was in the service of the Bakufu (Tokugawa) government. Gakutei's mother later married a Mr. Yashima and took her son into the Yashima family. Most of his surimono he signed "Gakutei," "Gakutei Harunobu," or "Sadaoka Gakutei." But like other artists he still used six or seven additional pseudonyms.

As to the number of his surimono, Gakutei ranks third after Hokkei and Shinsai and before Hokusai; however, it is not the number but the high quality of Gakutei's surimono which deserves highest praise. His surimono are skillfully executed,

printed with great precision, and beautifully coloured. He often covered open spaces on his surimono with repeated patterns of flowers or other printed designs. Frequent themes were ladies playing on the *koto* (13-string instrument), flute, or *biwa* (lute), still life or scenes from Japanese or Chinese legend and history. Gakutei lived for more than 80 years and died in the early Meiji period.

We mentioned that Gakutei designed a few landscape prints of large size (not surimono). Most famous is the series *Tempō-zan Shōkei Ichiran* (Famous Views of Tempō-zan). This is an album of poems, six pictures, and a charming cover picture by Gakutei (signed "Gogaku"). Tempō-zan views are also in Hokusai's and Hiroshige's prints, but they are not better than Gakutei's album landscapes.

KATSUSHIKA HOKUÜN (worked *ca.* 1805–40)

Hokuün was a carpenter before he became an artist. Louis Gonse thought that Hokuün and Hokusai were one and the same person, so similar were the works of the two artists in Gonse's eyes. Like Hokusai, Hokuün published a *manga* collection (sketches, drafts, etc.). Later he moved to Nagoya, his birthplace.

SHŌTEI HOKUJU (worked late 1790's to mid-1820's)

The earliest known work of Hokuju's is a surimono dated 1802. His landscapes preceded most of Hokusai's landscapes, for all of Hokusai's most famous ones were dated after 1830, according to modern researchers. Yet Hokuju never equaled Hokusai's stature. Hokuju was considered an expert in painting cloud formations. It is characteristic of Hokuju that the sky is predominant in his paintings.

YANAGAWA SHIGENOBU (1786–1832)

Shigenobu was Hokusai's son-in-law and the father of Hokusai's grandson. Shigenobu's pseudonym was Raito. He designed a series of *One Hundred Beautiful Women* and another series, *Five Poetesses*. He also portrayed actors and landscapes. Unfortunately, he sometimes forged Hokusai's paintings. His style is a mixture of Hokusai's and the Utagawa school. In 1822 he moved to Osaka, where he painted actors playing their roles and taught a few students. He supposedly had a considerable influence upon the artists in the Kansai district. Later he became a puppet carver.

UTAGAWA TOYOKUNI II (1777–1835)

Toyokuni II used the *gō* of Kōsotei and Ichieisai. He was also known as Toyo-shige. In 1824 Toyoshige was adopted by Toyokuni, who died a year later, and Toyoshige received the prestigious name of Toyokuni II. He designed *bijin-e*, *yakusha-e*, landscapes, yet could never compare with Kunisada or assert himself against him.

UTAGAWA KUNISADA (1786–1864)

Kunisada's real name was Sumida Shōzō; he was born in Edo. He used the name Ichiyūsai as his *gō*. Often he signed his pictures with "Gototei" (meaning "fifth ferry establishment"). The ferrying business, which Kunisada had inherited from his father, freed him from financial worries for his entire life. As a boy of 15 or 16, he entered Toyokuni's school, but left in 1806. Kunisada was a gentle, cheerful man, who was known and loved everywhere, and finally reached fame although he painted almost nothing but beautiful women and actors.

In his landscape paintings (famous places in Edo), figures are most prominent and the landscape, though skillfully designed, is of secondary importance. He designed more than 20,000 pictures. Publishers were eager to buy his works, and Kunisada insisted on high prices and immediate cash payment, which was quite unusual among ukiyo-e artists; but Kunisada had learned this practice from Toyokuni.

For a time Kunisada called himself Toyokuni II, but the family council objected to it since this prestigious name had already been bestowed upon another one of Toyokuni's pupils, Toyoshige. It was asserted, although supposedly falsely, that Toyokuni's widow married Toyoshige. For that reason Kunisada left the Utagawa school in 1828 and worked independently in Yanagishima. Later, Kunisada was called Toyokuni III; but the pictures signed as Kunisada are better than those with the signature Toyokuni III.

Naturally, among the 20,000 pictures there are some of lesser quality. But there are also unsurpassed masterpieces among them. There was a time around 1900 when French collectors refused to have anything to do with Kunisada because publishers had made hundreds of copies more than the printing plates could adequately yield. Thus, low-quality Kunisada prints had come into circulation. Kunisada had

been far too industrious and consequently the art dealers and importers were offering an overabundance of his works.

At an advanced age, Kunisada composed many pictures of ladies at their morning toilette and similar situations. They are pictures in which a bare leg or breast is visible. Today one calls such pictures *abuna-e* (dangerous pictures). Of course, Kunisada also designed erotic pictures and connoisseurs assert that these particularly reveal Kunisada's talent.

Kunisada designed many surimono of beautiful women, actors, heroes, and animals but, apparently, no still lifes. Kunisada's best pupils were Sadahide and Sadakage; both designed beautiful surimono.

UTAGAWA KUNIYOSHI (1797–1861)

Kuniyoshi was younger than Kunisada and died a few years earlier. His real name was Igusa Magosaburō, and he was the son of an Edo merchant who sold dyed textiles. Even as a child, Kuniyoshi is reported to have loved beautiful colours and, particularly, heroic paintings by Shigemasa. Thus, he was sent to Toyokuni as an apprentice at the tender age of 12. At that time, Kunisada had already become a master, while Kuniyoshi did not receive his diploma until 1814; after that he illustrated several books.

Kuniyoshi's *gō* was Ichiyūsai. He became a great artist, although he was quite different from Kunisada. Kuniyoshi, like so many artists, squandered his money; he took good care of his wife, children, and pupils, but he was unable to save any money.

His portraits of women are not very appealing, but his battle scenes and portraits of heroes display power and great talent. His masculine portraits in the series *Fifty Heroes of Taiheiki* are outstanding, as are his scenes from the eleventh act of *Chūshingura* (staging the final battle of the 47 *rōnin*). Kuniyoshi's landscapes were different from those by Hokusai and Hiroshige. He kept them on a small scale in the background of pictures of heroes or other figures.

Kuniyoshi was an opponent of the Tokugawa regime, and although he was very outspoken, the authorities did not take action against him. During his lifetime, Kuniyoshi never reached the fame of Kunisada, who was a more elegant and gregarious person. But their relationship was harmonious. Posterity has shown

Kuniyoshi greater esteem than his contemporaries ever did. Professor Speiser's book *Kuniyoshi* was developed from the illustrated handbook edited by B. W. Robinson for the Victoria and Albert Museum memorial exhibit. That exhibit commemorated the one hundredth year since Kuniyoshi's death. The museum owns 2,500 woodblock prints by the artist.

KIKUKAWA EIZAN (1787–1867)

Eizan is the founder of the Kikukawa school which produced many pupils whose names all begin with "Ei." But among them there is none worth mentioning in connection with surimono; the exception being Eizan himself and the great Keisai Eisen, who called himself a pupil of the former although he actually never worked under him.

Eizan was related to Toyokuni but he resisted the influence of the Utagawa school. He followed the example of Utamaro, but painted his beautiful women in a manner quite different from Toyokuni and Kunisada, using vivid colours and more pronounced contours. Eizan's women are more naïve—one might say beautiful but not very intelligent. In Eizan's time Utamaro was already out of fashion so that Eizan's pictures were somewhat behind times and less appealing to his own generation. Nevertheless, Eizan, who did his first ukiyo-e at the age of 16, was in 1807 already recognized as a master. He published several series of *bijin-e* and was one of the first to produce *kakemono-e*.

KEISAI EISEN (1790–1848)

Eisen surpassed his teacher, Eizan. As a matter of fact, Eisen wasn't even a pupil; he only lived for some time in the house of Eizan's father, and when Eizan's daimyō decreed that the entire family should paint, Eizan published Eisen's pictures. Eizan's manner of painting had become outdated, for the pictures of the Utagawa school had come into fashion. Young Eisen was, of course, conscious of this.

Eisen devoted his entire life and almost his whole art to women, that is, to the beauties of the pleasure quarters of Edo. When he was still a young man, he led an extremely disorderly and immoral life; he reputedly maintained his own house of beautiful young singers. He once said, "What's wrong with spending like water the money I earned myself?" Later Eisen reformed somewhat. Yet he continued

to portray beautiful courtesans whenever he painted women. They are marvelous pictures, full of life and beautiful colours.

Eisen is at the very least an equal of Kunisada. Willy Roller called Eisen a "Titan Figure." Eisen's women are usually somewhat decadent with a strange sensuality, whereas Kunisada's women are simply sensuous. Eisen proved to be independent as a landscapist too. His moonlit and snowy landscapes are famous. Twenty-three of Hiroshige's *Sixty-nine Scenes of the Kiso Road* are by Eisen. This series was originally Eisen's but he failed to complete it, so his publisher asked Hiroshige to finish the job. Eisen's paintings of Edo's Shinobazu Pond and of the Nihombashi Bridge are famous. In addition, he portrayed landscapes and animals. But again and again, he painted beautiful women on large *nishiki-e* as well as on surimono. Using the *gō* "Keisai," he painted many erotic pictures, but never surimono. Erotic pictures were bought for one's own use or for newly wed couples in the family, but probably never as congratulatory gifts. Another member of the Kikukawa artist-family was Kikukawa Eishin, who, like Eisen, designed numerous surimono.

WATANABE KAZAN (1793–1841)

Kazan's name was Watanabe Sadayasu. He was born in Edo and acquired the style of the modern Chinese Nanga school. Kazan took what he found useful from this school and, by adding the European manner of painting, thus developed his own style. For his surimono, Kazan often chose unusually small or abnormally wide sizes. His specialities were flowers, birds, and portraits. He had the misfortune of being wrongly accused by the Bakufu government and was sentenced to house arrest. In 1841 he took his own life.

ANDŌ (UTAGAWA) HIROSHIGE (1797–1858)

Hiroshige is Japan's greatest landscape painter; as such he is known all over the world. Some of his great works, among them the *Fifty-three Stations of the Tokaido* (1832–33), have been reproduced in Japan as well as in many other countries. Hiroshige is mentioned in all modern art histories of landscape painting, and in every large European or American ukiyo-e collection Hiroshige's pictures of landscapes, flowers, and birds are predominant. He did not, however, design many surimono.

One Hiroshige surimono each can be found in the Straus-Negbaur Collection,

P. W. Meister Collection, and the Ueno and Happer catalogues of surimono.
Most likely Hiroshige had designed surimono as a young man until he discovered his great talent for landscapes. Other series are the *Tōto-Meisho* (Famous Places in the Capital of the East), the *Eight Views of Lake Biwa,* and *Seventeen Stations of the Kiso Road.*

With Hiroshige we conclude our survey of the most important surimono designers. There are, to be sure, many contemporaries of the masters discussed here, as well as a host of pupils and imitators who kept this art alive until a gradual decline of multicoloured woodblock prints set in soon after the first quarter of the nineteenth century. The landscape artists (Hokusai, Hiroshige) brought a revival in the 1830's. The end came after the middle of the nineteenth century when the last great artists had died, when the last skillful printers and woodblock carvers had vanished, and when Commodore Perry forced the Tokugawa government to open Japan's harbours to foreigners.

Of course it would be an exaggeration if we would say that after Hiroshige an artistic vacuum followed. In a country where every second or third man is a talented draftsman a vacuum is impossible, but during the last years of the toppling Tokugawa government and during the first years of the imperial Meiji period, the Japanese were preoccupied with other, more important matters and could not concern themselves with the arts.

To be complete, however, we will add a few lines regarding a few artists who worked after Japan had opened its ports to foreigners. The so-called *Nagasaki-e* and *Yokohama-e* served to show to the highly interested Japanese people how the foreigners lived, their daily occupations, their houses, ships; and their red hair, green eyes, and long noses. But these pictures were without any artistic value, although they were designed by pupils of Hiroshige, Kunisada, and other masters. The painters in the Kamigata (Kyoto and Osaka) district also did not produce anything of great value during this time.

Thus the Meiji period brought the restoration of the imperial central government, but for the woodblock prints it brought the end or let us say an interruption for almost one hundred years. Printing machines, new dye stuffs, and cameras

were imported and displaced the process of printing by carefully carved wooden printing blocks.

The Meiji Period

SHIBATA ZESHIN (1807–91)

An artist who in the Meiji period occasionally designed good surimono was Shibata Zeshin. He studied at the Shijō school, lived and worked in Tokyo. His specialities were birds and flowers.

UTAGAWA HIROSHIGE II (1826–69)

Hiroshige II was a fairly good artist. He was the son-in-law of Hiroshige I, but left the family and moved to Yokohama. There he designed pictures for export tea boxes and later, back in Tokyo, he designed good landscapes, birds, and flowers, etc.

TSUKIOKA (TAISO) YOSHITOSHI (1839–92)

A former member of Kuniyoshi's school, Yoshitoshi designed warrior prints and painted newspaper pictures like his teacher. He loved to frighten the people with cruelly grotesque printed pictures. Finally he became insane. But Yoshitoshi had 80 pupils!

KOBAYASHI KIYOCHIKA (1848–1915)

The best *ukiyo-e-shi* of the Meiji period was Kobayashi Kiyochika. He came from Shizuoka to Yokohama, learned photography under one of Japan's leading photographers and oil painting from an Englishman. Later he studied Japanese painting. Passing through the newer copper-engraved and lithographic prints, his taste finally turned to Japanese woodblock prints. Kiyochika left really remarkable prints in his own style which, after being forgotten for a long time, are now deservedly admired.

Four : COLLECTIONS

Collecting Surimono

A few words must be said about collecting surimono. Unfortunately, not many of the surimono have been preserved, since they were single sheets distributed as gifts among friends. It is an old story that a gift is sometimes less valued than an object for which one has paid a sum of money. At any rate, some Japanese immediately glued a new surimono to book covers, wall screens, or to the pages of an album. The surimono on book covers and wall screens were faded by the sun, or perhaps fell into the hands of small children or unappreciative heirs.

One album containing 72 surimono from the competitions of 1823 which was purchased by Dr. Julius Brinckmann was in the Hamburg Arts and Crafts Museum. Louis Gonse writes of *une demi douzaine* (one half-dozen albums) in his time—the end of the nineteenth century—which were in the private possession of two or three collectors in Paris. Of these Gonse comments: "Seldom does one find two surimono alike in such collections; the numbers of the copies produced were small."

The largest surimono collection in the world (approximately 1,200 pieces) is in the Fogg Museum in the Harvard University, Cambridge. For surimono this figure is quite high, but considering the number of *ōban* ukiyo-e published and sold commercially, it is comparatively small.

53

Woodblock print dealers in Tokyo and Osaka for a number of years have been unable to buy and sell surimono. They sell reprints and occasionally dirty or faded originals. The best surimono collection in Tokyo is probably the collection owned by Professor Fujisawa Eihiko which was exhibited August, 1963 at the Odakyū Department Store.

Notes on Museums and Collections

The following list of museums and collections has been compiled exclusively from the author's notes. All museums are listed under the name of the city in which they are located.

MUSEUMS

AMSTERDAM. The Rijksmuseum in Amsterdam owns a fine surimono collection from the late Mr. J. A. Bieren de Haan. This collection includes works by almost all the artists who designed surimono. A catalogue has not yet been made.

CAMBRIDGE. The Fogg Museum in the Harvard University compound, as previously noted, possesses a surimono collection which certainly is the largest in the world. Mr. Usher F. Coolidge from the Associate Oriental Department was kind enough to send me a copy of the museum's Index, because unfortunately the collection has not yet been catalogued. The Index helps to clarify a few matters that have been dubious up to now. In this great collection there is not one piece by Harunobu. Does this prove that Harunobu did not design surimono, or that he perhaps designed only a few calendar prints? Compared with other collections there are very few (only 14) surimono without artist's signatures. Some artists (about nine percent) did not sign their prints, while the amateur poets never failed to sign their *kyōka* on surimono. The great painters of female beauty in the so-called Golden Age are not so well represented: Shunshō, 2 prints; Kiyonaga, 1; Eishi, 4; Utamaro, 6. They designed surimono—as the Fogg Museum collection proves—but evidently not many. Hiroshige designed considerably more than

the author had expected. He designed them in his younger years before he made
his name as a great painter of landscapes, flowers, birds, and fishes.

The European and American predilection for Hiroshige and Hokusai, i.e., artists influenced to a certain degree by European taste and touch, manifests itself also in the Fogg Museum's great collection. The museum owns 81 surimono by Hokusai, 201 by Gakutei, 56 by Hokkei, 67 by Shinsai, and 20 by other pupils and followers of Hokusai. Hiroshige contributed 23 prints. There are still more valuable gems in this unmatched collection. To catalogue it would be a great service not only for collectors but for all lovers of Oriental art.

DÜSSELDORF. The Kunstmuseum from time to time exhibits ukiyo-e. From May to June of 1966 the museum organized a remarkable exhibition, Die Osaka Meister (The Osaka Masters). A catalogue of 84 pages with 104 black-and-white illustrations was printed, but only one surimono was reproduced.

HAMBURG. The Museum für Kunst und Gewerbe owns a fine collection of about 300 surimono collected by the museum's former director, Dr. Julius Brinckmann, when he visited Japan at the end of the nineteenth century. All ukiyo-e artists are well represented. Plates 12 and 32 of this book were made from the originals of the museum. A catalogue has not yet been made.

COLOGNE. The director of the Museum für Ostasiatische Kunst, Professor W. Speiser, favoured Kuniyoshi and Kunisada more than all other Japanese woodblock-print designers. He wrote an introduction for B. W. Robinson's book *Kuniyoshi,* and made an illustrated catalogue of 37 pages for a Kuniyoshi exhibition which he organized in 1963 in the Eigelsteinburg. One hundred and twenty-eight ukiyo-e were exhibited, but no surimono. Nevertheless, Kuniyoshi designed a great number of fine surimono.

After Professor Speiser's death, a friend and fellow print collector, Mr. Willibald Netto, in 1966 organized a similar exhibition for Kunisada in the copper-engravings department of the Wallraf Richartz Museum. Mr. Netto also wrote the text (44 pages) of the catalogue in which 20 of the 71 exhibited ukiyo-e were depicted. Five surimono by Kunisada were shown in this exhibition.

PARIS. The Japanese newspaper *Nihon Keizai Shimbun* and the Union Centrale (Musée) des Arts Décoratifs organized a large Japanese print exhibition in Paris in 1966. The exhibition was located in the Pavillon de Marsan in the Louvre. The catalogue was prepared in Tokyo by Messrs. Suzuki Jūzō, Harry Packard, and Jean Mounin. The title is *Images du Temps Qui Passés*. Pages 9–23 give the history of ukiyo-e. Then follows the Introduction, 6 pages of coloured reproductions, and 74 pages of black-and-white illustrations. Lists and biographical notes comprise 16 pages; 55 pages describe the exhibited prints and hand-painted pictures, and 427 prints plus famous series by Harunobu, Hokusai, Kunisada, and Hiroshige were exhibited. The prints were lent for the exhibition by 31 print collectors in Japan. Among them were Aoki Tetsuo, Suda Shunsaku, Nakajima Shin'ichirō, and N. C. H. Mitchell.

ROTTERDAM. Museum Boymanns van Beuninggen some years ago held a surimono exhibition. A catalogue was printed and the well-known connoisseur, Mr. C. Ouwehand, wrote a three-page preface. The 109 exhibited surimono were described on 13 pages and 20 surimono reproductions in black and white illustrated the catalogue. The catalogue is in Dutch.

TOKYO. The Tokyo National Museum has a fine collection comprising altogether 14,000 prints (*ōban* ukiyo-e). Monsieur Henri Vever in Paris collected 8,209 prints. Mr. Matsukata Kōjirō, the founder of the Matsukata concern (shipyards, iron and steel works, and machinery), bought the collection in 1921 and brought it home to Japan to present to the national museum. The catalogue, in three volumes, is illustrated with 3,926 reproductions in black and white. These include 112 surimono: Kiyonaga, 1; Shumman, 20; Chōki, 2; Kuniyoshi, 10; Hiroshige, 2; Hokusai, 73; Shigenobu, 1, and Hokkei, 3. The catalogue is in Japanese and English.

COLLECTIONS

BRANDT. Paul Brandt in June, 1966 sold in his auction room in Amsterdam 490 Japanese woodblock prints. Among them 34 were surimono. The 254-page catalogue was richly illustrated and expertly written in English by Paul Brandt, Jr.

FUJISAWA. Professor Fujisawa Eihiko's surimono collection was twice exhibited in one of the large department stores in Tokyo's Shinjuku district. Professor Fujisawa is the president of many institutes and associations in Japan. Specialized exhibitions in the great exhibition rooms of department stores are much appreciated by the Japanese public. The professor's surimono were seen by many thousands of interested visitors. The catalogue (in Japanese) of his second exhibition listed 245 surimono, among them: Utamaro, 1; Shumman, 44; Shinsai, 58; Hokusai, 22, and Hokkei, 19. There were 11 unsigned prints. The first exhibition was on a similar scale.

JAPAN UKIYO-E SOCIETY. This society in Tokyo from time to time organizes exhibitions of prints belonging to members of the society in department-store halls. In two exhibitions which the author remembers 321 ukiyo-e and 327 books illustrated with coloured woodblock prints were exhibited. To the author's regret, however, there were no surimono. The exhibition's catalogues are, of course, in Japanese.

MOSLE. A catalogue for the collection of Alexander G. Mosle was published in 1909 by the Königliche Kunstgewerbe Museum in Berlin under the title *Japanische Kunstwerke*. The catalogue has 385 pages. Pages 282–337 deal with 376 woodblock prints; pages 329–39 describe exhibited surimono: Hokusai, 7; Hokkei and other Hokusai pupils, 45. The remainder are by Toyokuni, Toyohiro, and their pupils. Altogether there are 61 surimono and 294 *ōban* ukiyo-e.

RIESE. Dr. Otto Riese's fine collection was exhibited twice, first in the Kantonale Museum für Schöne Kunst in Lausanne, Switzerland in December, 1965, and second in Ingelheim, West Germany in May, 1967. The catalogues for both exhibitions were compiled by Dr. Rose Hempel. From the point of view of an art historian, Professor Riese's collection—from Moronobu to Hiroshige—is remarkably well put together. In Lausanne 138 *ōban* ukiyo-e and 4 surimono were exhibited; in Ingelheim, 24 prints more which Professor Riese had added to his collection after 1965. In Ingelheim, moreover, the visitors had the opportunity to inspect 12 charming surimono and a few *e-goyomi*. A historical introduction, short

biographical remarks about the artists, and descriptions of *ōban* ukiyo-e and surimono were made by Dr. Rose Hempel in both catalogues.

SCHEIWE. Theodor Scheiwe's collection in Münster, West Germany was exhibited in 1959 in Wolfsburg by Dr. Nordhoff, who at that time was the director of the Volkswagen automobile factory. Dr. Rose Hempel catalogued Mr. Scheiwe's fine collection, wrote the Preface and an article of seven pages about surimono, besides describing the pictures and writing short biographies of the artist-painters in her scientific way. Small black-and-white reproductions including nine colour plates are given for the 310 *ōban* ukiyo-e and 37 surimono designed by Edo artists. A great merit of the collector and Dr. Hempel, however, is that for the first time Kamigata surimono (from the district in and around Osaka and Kyoto) were exhibited and included in the catalogue. Compared with Edo surimono, Kamigata surimono are not so charming, but they are well worth collecting and studying.

SOLF. Dr. Wilhelm Solf collected *ōban* ukiyo-e, and in particular pictures of ghosts, earthquakes, Nagasaki, and Yokohama foreigners. He also favoured surimono. His prints were shown in Germany twice, first in 1933 in Leipzig and the second time for an auction in Berlin on June 19, 1936. In Leipzig 22 surimono were exhibited: Toyohiro, 1; Shumman, 1; Hokusai, 5; Gakutei, 6; Hokkei, 4; Kunisada, 1; Hiroshige, 2, and unsigned, 2. The surimono shown in Leipzig were not among the 203 ukiyo-e and 106 surimono sold at the auction. The auction's catalogue is illustrated, but only three surimono by Hokkei and five by Gakutei are depicted.

STRAUS-NEGBAUR. The Tony Straus-Negbaur Collection was sold at auction in June, 1928. The auction's catalogue was titled *Japanische Holzschnitte*. The Introduction was written by Curt Glaser, the descriptions by Fritz Rumpf—both famous art historians. Sold were 637 ukiyo-e including 37 surimono by Harushige, Shumman, Toyohiro, Hokusai, Gakutei, and others. The catalogue is beautifully illustrated; six surimono by Shumman are reproduced.

The Surimono

1. A courtesan of the highest rank. Attendants accompany her. 1810. Signed: Hokusai *ga* (Katsushika Hokusai). Size: 20.3 × 13.5 cm. (8 × 5¼ in.)

2. Official calendar for the year Bunka 7. This print gives information for the New Year such as the long and short months. 1810. Unsigned. Size: 15 × 21.5 cm. (6 × 8½ in.)

年中神佛㕣詣之行事

文化七庚午歳〔うしとくのとしのる　うしとうのるとの〕金神　うし

庚申　五日
宿坊　する
大師　うん

甲子　九日

己巳　十四

	大小	二	三	四	五	六	七	八	九	十	十一	十二
庚申	五日		六日		八日		八日		九日			
甲子	九日	十日	十一		十二		十二		十三			
己巳	十四	十五		十六		十七			十八			

朔日辰酉卯申寅申丑未丑午子巳

初午　二月十日　三月一日
八梅　五月九日　六月二日　羊夏
二月廿四日　八月廿六日　四月一日
小カン　十二月十二日　十一月廿七日
大カン　玄十月廿六日　酉十一月廿日
猪十月六日　町

	寅ノ日		午ノ日	
七	正廿一	七	正十三月	
二	八	二	八	
三	九	三	九	
四	十	四	十	
五	十一	五	十一	
六	十二	六	十二	

3. Calendar print with picture. 1810. Unsigned. Size: 12 × 16 cm. (4¾ × 6⅜ in.)

4. Calendar print for the year Bunsei 5. Tobacco Pouch. 1822. Signed: Eizan (Kikukawa Eizan). Size: 8 × 12 cm. (3⅛ × 4¾ in.)

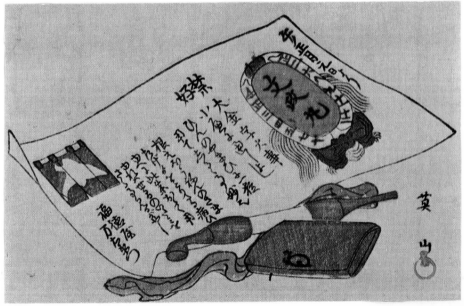

5. Calendar print for the year Bunka 7. A magnificently dressed young lady leads a wooden horse which carries a bird cage on its saddle. 1810. Signed with seal: Shumman (Kubo Shumman). Size: 20.5 × 13 cm. ($8\frac{1}{8} \times 5\frac{1}{8}$ in.)

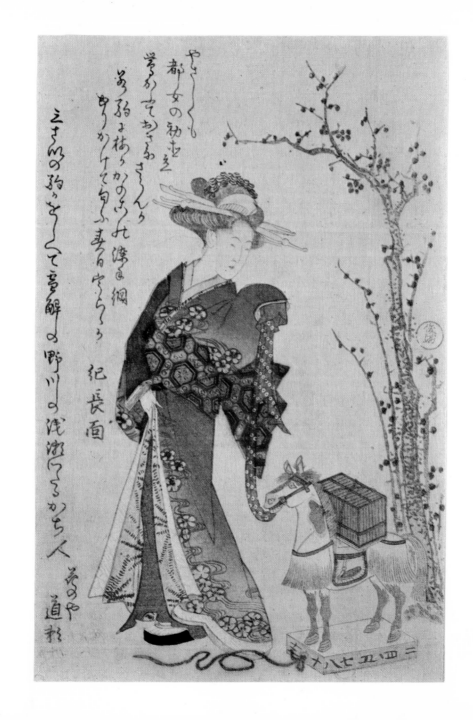

6. Twelve fans with actor's portraits. Males appear for long months; females for short months. Calendar print for 1787. Signed: Shunshō *ga* (Katsukawa Shunshō). Size: 13 × 17 cm. ($5\frac{1}{8}$ × $6\frac{3}{8}$ in.)

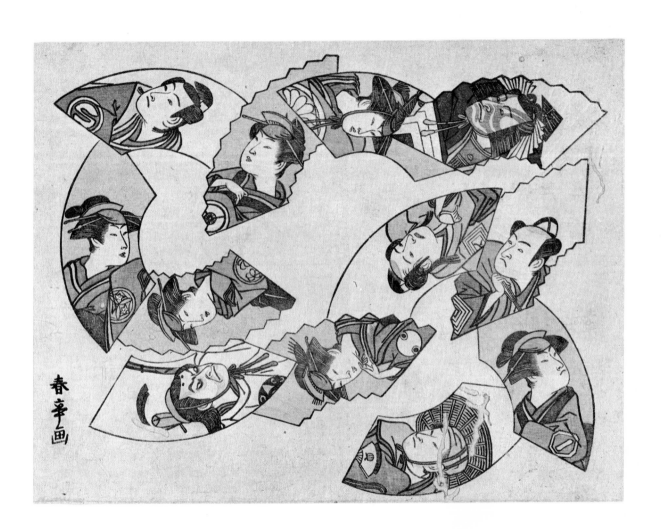

7. Four New Year amusements, "kin-ki-sho-ga." The amusements were music *(koto)*, games *(go)*, calligraphy *(sho)*, and drawing *(ga)*. 1787. Signed: Toyoharu *ga* (Utagawa Toyoharu). Size: 13 × 17 cm. (5$\frac{1}{8}$ × 6$\frac{3}{8}$ in.)

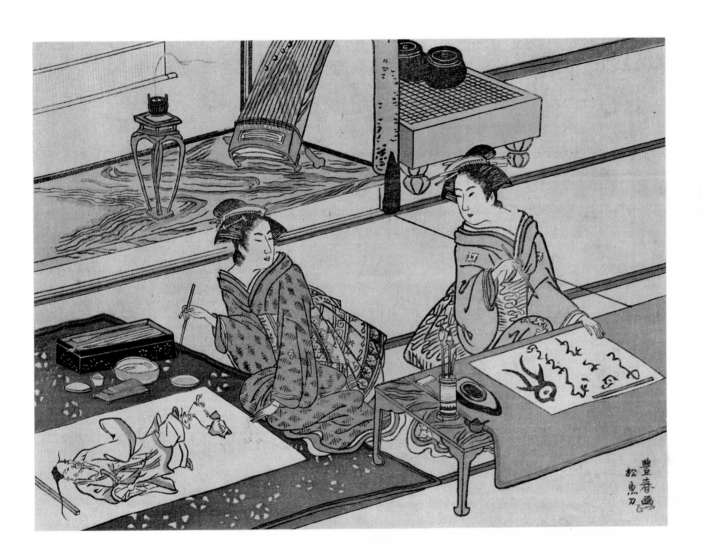

8. Shrine beneath an old pine tree. Signed with seal: Shumman (Kubo Shumman). Size: 19×17 cm. ($7\frac{1}{2} \times 6\frac{3}{4}$ in.)

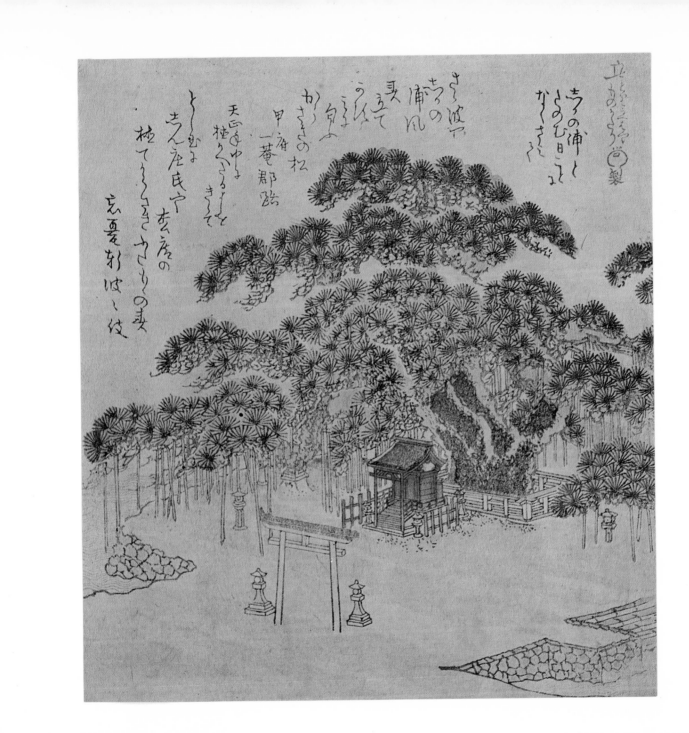

9. Wrestling animals. Kintarō is referee; his mother is looking on. Signed: Keisai (Keisai Eisen). Size: 21 × 19 cm. (8¼ × 7½ in.)

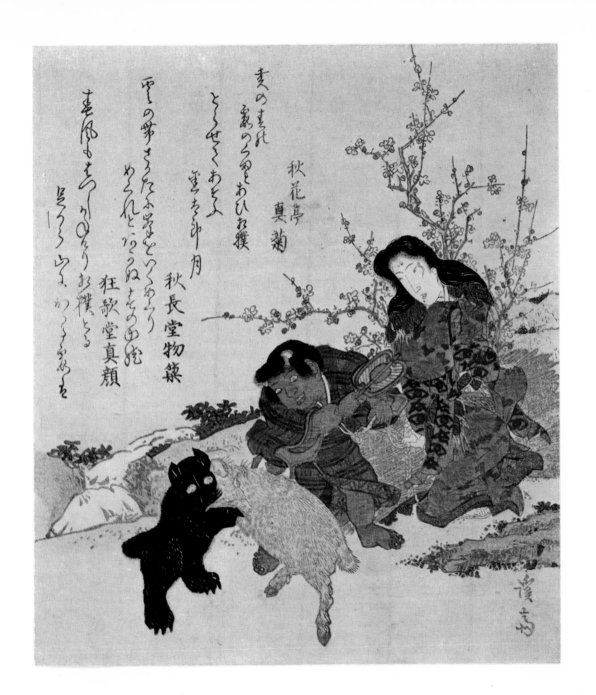

10. Landscape and still life. Signed: Keisai (Keisai Eisen). Size: 19×17 cm. $(7\frac{1}{2} \times 6\frac{3}{4}$ in.)

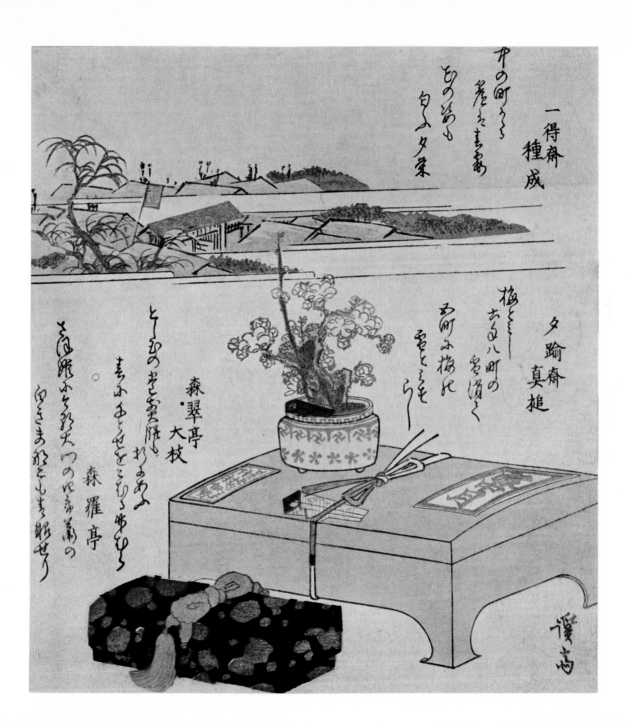

11. Tiger and knight. A surimono for the year of the tiger. Signed: Toyokuni *hitsu* (Utagawa Toyokuni). Size: 20.5 × 13 cm. (8¼ × 5¼ in.)

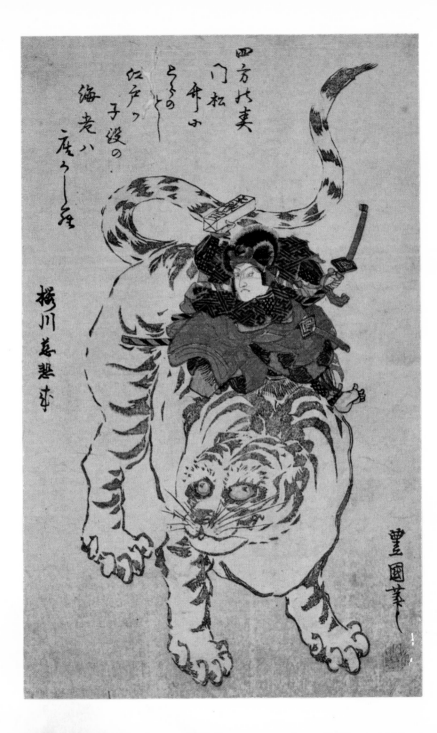

12. Ichikawa Danjūrō VII (1797–1859). The actor, in his "Shibaraku" play role. The child is dressed like Ebisu, the god of good luck. Signed: Toyokuni *ga* (Utagawa Toyokuni). Size: 20.7 × 18.8 cm. (8⅛ × 7⅜ in.) Collection of the Museum für Kunst und Gewerbe, Hamburg.

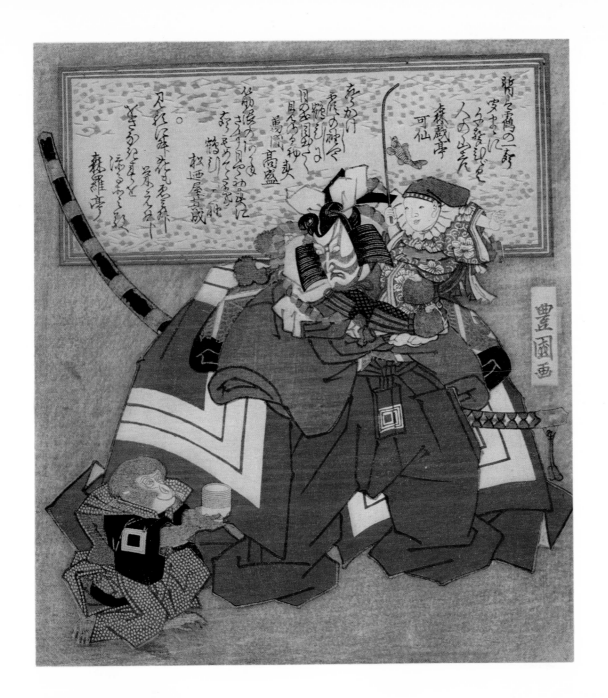

13. Design for the New Year, the year of the horse. 1810. Signed: Toyohiro *ga* (Utagawa Toyohiro). Size: 18.4×8.4 cm. (7¼×3⅜ in.)

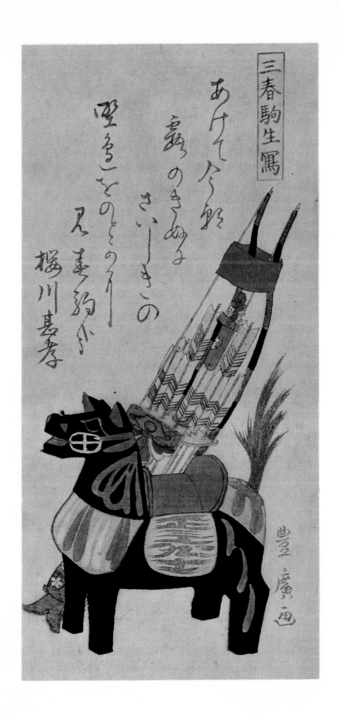

14. Young girl stepping from palanquin. She speaks
to a beautiful courtesan *(oiran)* whose obi is tied in
front. 1810. Signed: Toyohiro *ga* (Utagawa Toyo-
hiro). Size: 16.8 × 9.1 cm. (6⅝ × 3⅝ in.)

15. Landscape from Toyohiro's surimono series *Eight Scenes of Edo*. The picture shows Takanawa which today lies near the centre of Tokyo. Size: 25 × 18 cm. (9¾ × 7⅛ in.)

16. Kabuki villain drawing a hidden sword. The actor in "Modori Kago." Signed: Gototei Kunisada *ga* (Utagawa Kunisada). Sizes: 25 × 18 cm. (9¾ × 7⅛ in.)

17. Ichikawa Danjūrō V. Actor kneels before a pic-
ture of the Fudō. Signed: Gototei Kunisada *ga* (Toyo-
kuni III, also known as Utagawa Kunisada). Size:
21 × 18 cm. $(8\frac{1}{4} \times 7\frac{1}{8}$ in.)

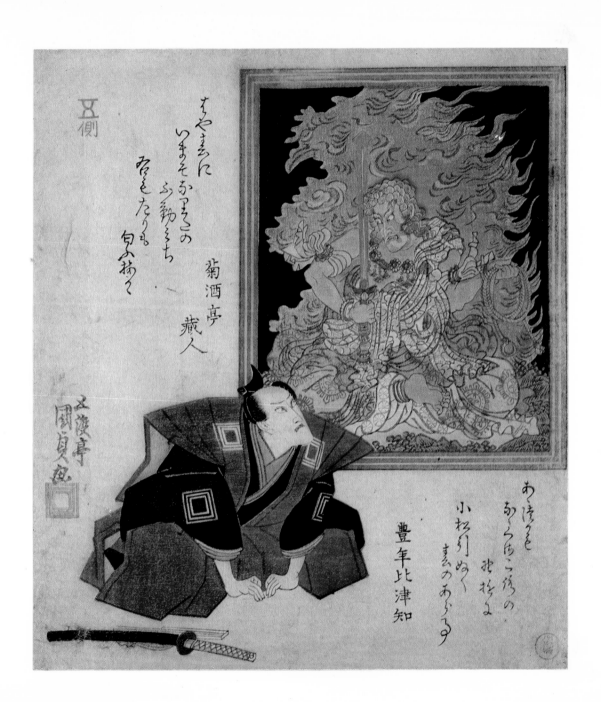

18. Warrior with halbert. Signed: Ichiyūsai Kuniyoshi *ga* (Utagawa Kuniyoshi). Size: 21.5 × 18 cm. (8½ × 7⅛ in.)

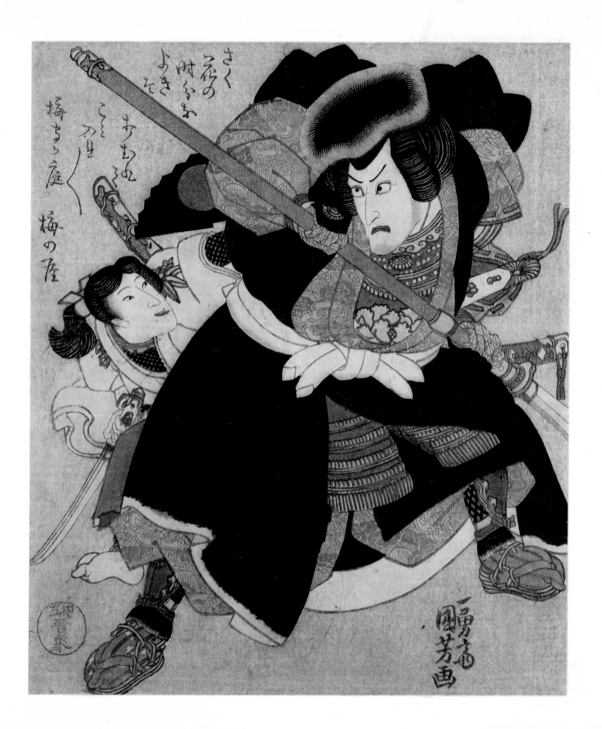

19. Lady hanging a scroll in her tokonoma. Signed: Ichiyūsai Kuniyoshi *ga* (Utagawa Kuniyoshi). Size: 21.5 × 19 cm. (8½ × 7½ in.)

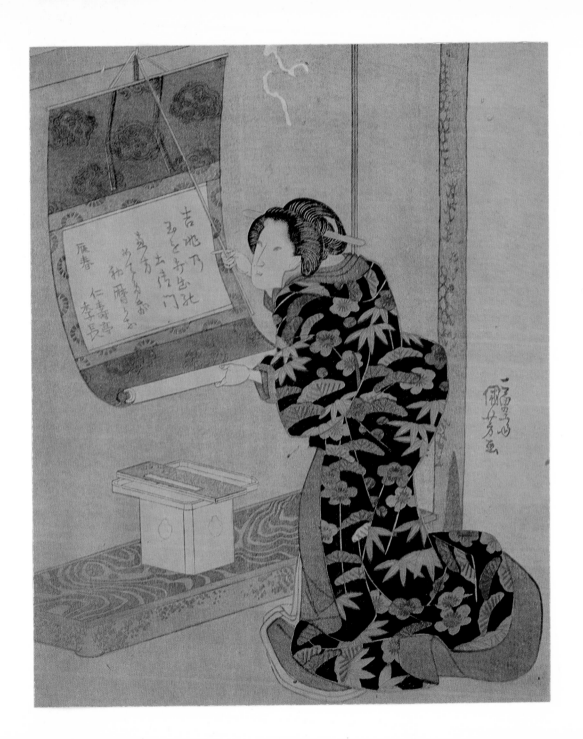

20. Courtesan writing first love letter for the New Year. From the series *Eight Scenes of Brothels*. Signed: Gokotei Sadakage (Utagawa Sadakage). Size: 20.5 × 18 cm. ($8\frac{1}{8} \times 7\frac{1}{8}$ in.)

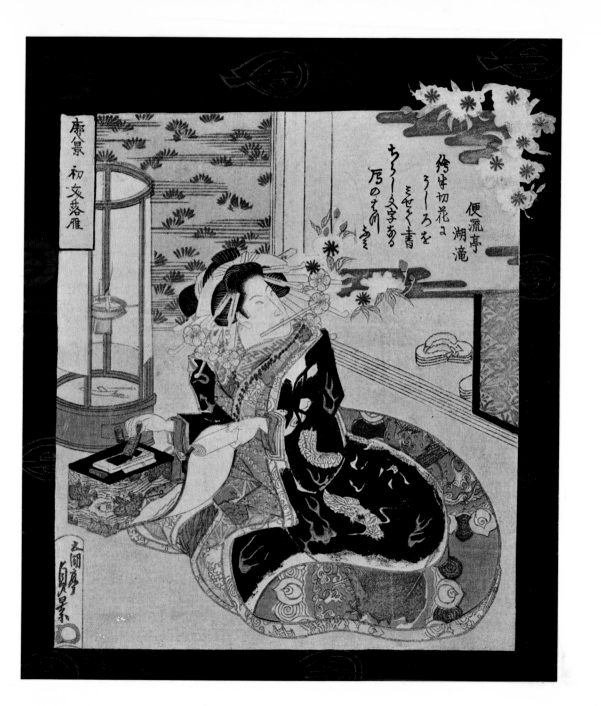

21. Three courtesans. The leading courtesan of the house tries to make peace between two young girls. Signed: Hokuma *ga* (Teisai Hokuma). Size: 14×28 cm. (5½×11 in.)

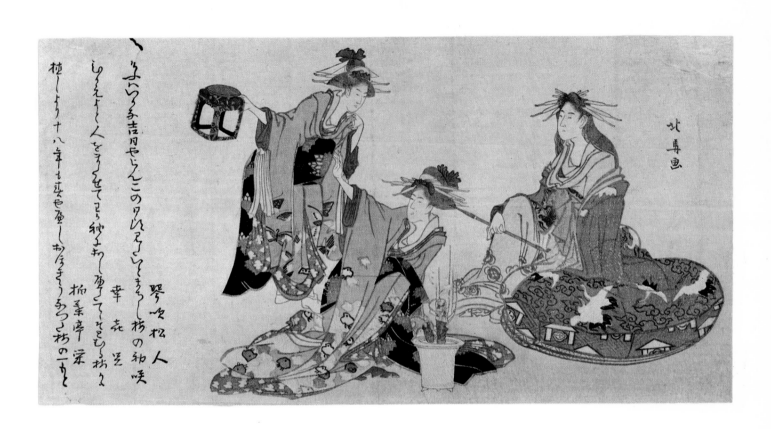

22. Mother and son with servant. The boy tries to draw his bow. Signed: Gakyōjin Hokusai *ga* (Katsushika Hokusai). Size: 14×18 cm. (5½×7⅛ in.)

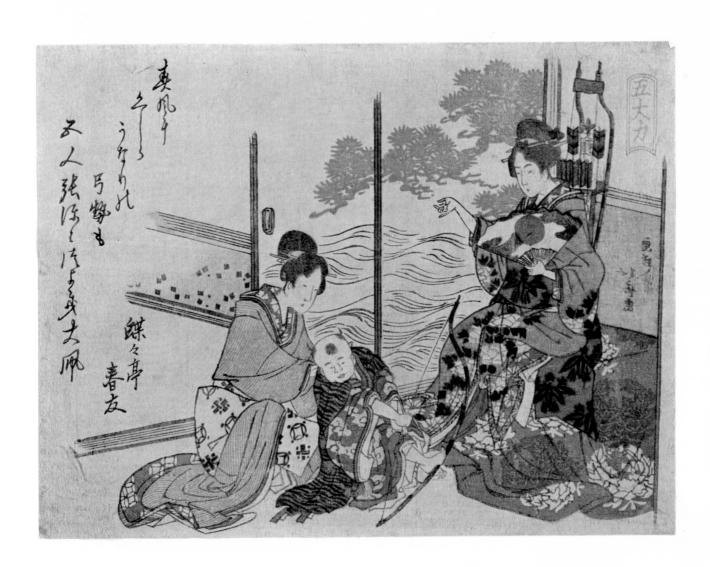

23. Peacock and hen. A roll of silk can be seen behind. Signed: Hokkei (Totoya Hokkei). Size: 21.2×18 cm. (8¾×7⅛ in.)

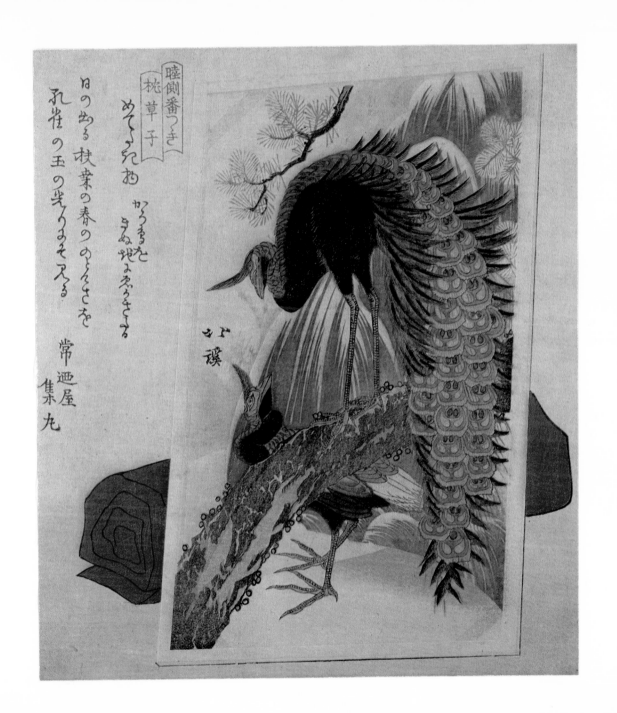

24. Climbing a waterfall. Kintarō, a strong and fearless boy, is shown with a carp. Together they symbolize courage and power. Signed: Hokkei (Totoya Hokkei). Size: 20.5 × 18.5 cm. (8 × 7¼ in.)

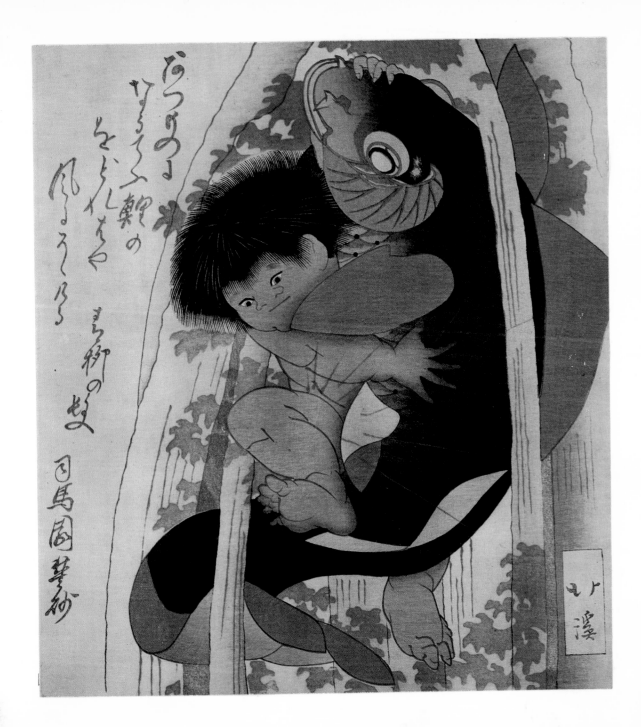

25. The giant Rochishin uprooting a tree. This surimono belongs to Hokkei's series *The Five Elements* (wood, fire, earth, metal, and water). The element here is wood. Signed: Go Hokkei (Totoya Hokkei). Size: 21 × 18 cm. ($8\frac{1}{4} \times 7\frac{1}{8}$ in.)

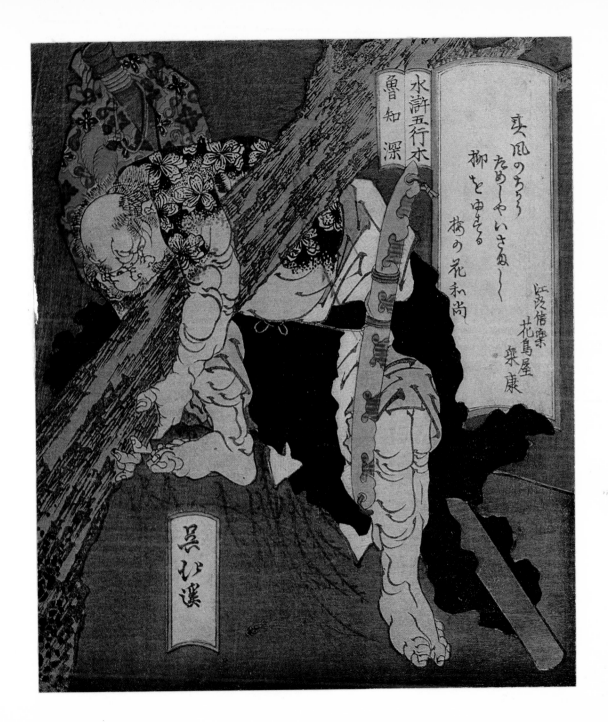

26. Benten and dragon. Signed: Yashima **Gakutei.**
Size: 20.5 × 18 cm. (8 × 7$\frac{1}{8}$ in.)

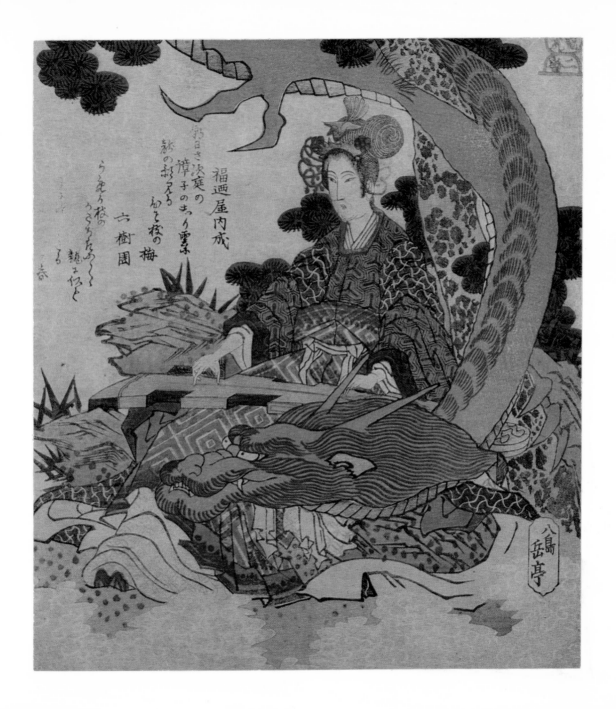

27. Girl showing kakemono. The background employs the symbol of happiness. Signed: Gakutei (Yashima Gakutei). Size: 21 × 18.5 cm. (8¼ × 7¼ in.)

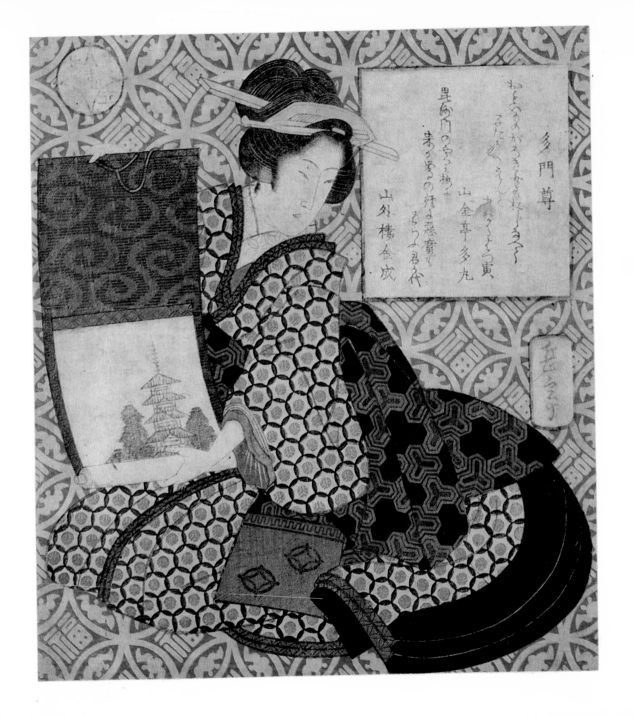

28. Still life. Shown are writing materials. A pot of *fukujusō* (Adonis) and screen signify longevity and happiness for the New Year. Signed: Gakutei (Yashima Gakutei). Size: 20.5 × 18 cm. (8 × 7⅛ in.)

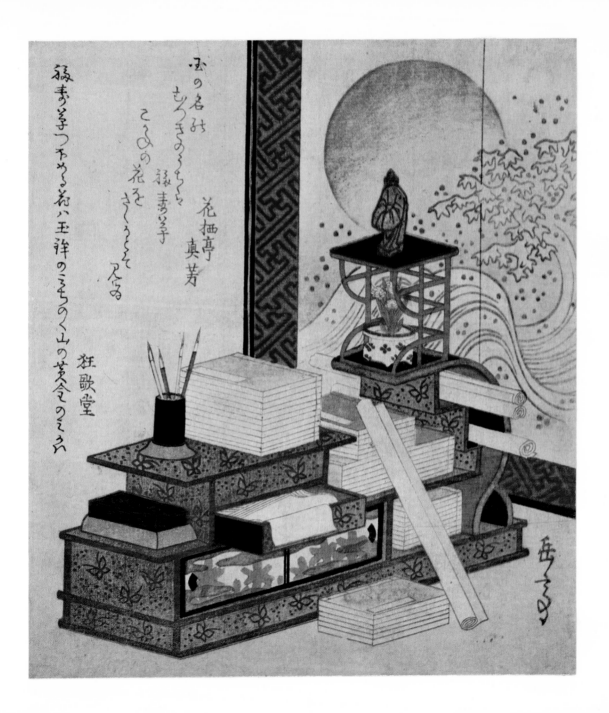

29. Still life of textile fabrics. This surimono belongs to Shinsai's famous series of 36 pictures, *Kasen Awase,* depicting ladies occupied domestically. Signed: Shinsai *ga* (Ryūryūkyo Shinsai). Size: 13.5×18.3 cm. (5¼×7¼ in.)

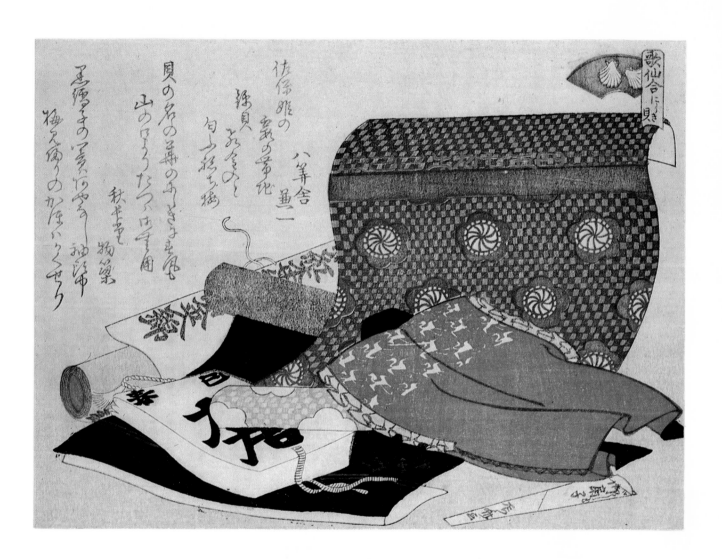

30. Courtesan before dressing table. Signed: Shinsai *ga* (Ryūryūkyo Shinsai). Size: 13.5 × 18.3 cm. (5¼ × 7¼ in.)

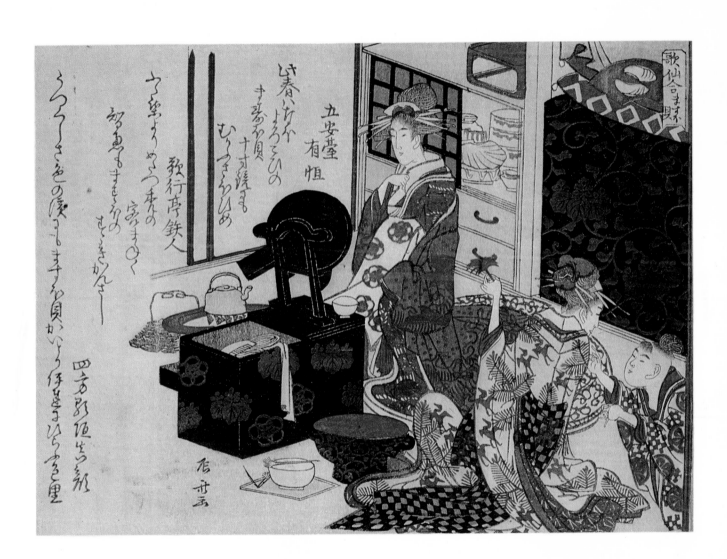

31. Izumi Shikibu. The famous poetess (eleventh century) is shown in this surimono belonging to Shigenobu's series *Five Poetesses*. Signed: Yanagawa Shigenobu. Size: 20.5 × 17 cm. ($8\frac{1}{4} \times 6\frac{3}{4}$ in.)

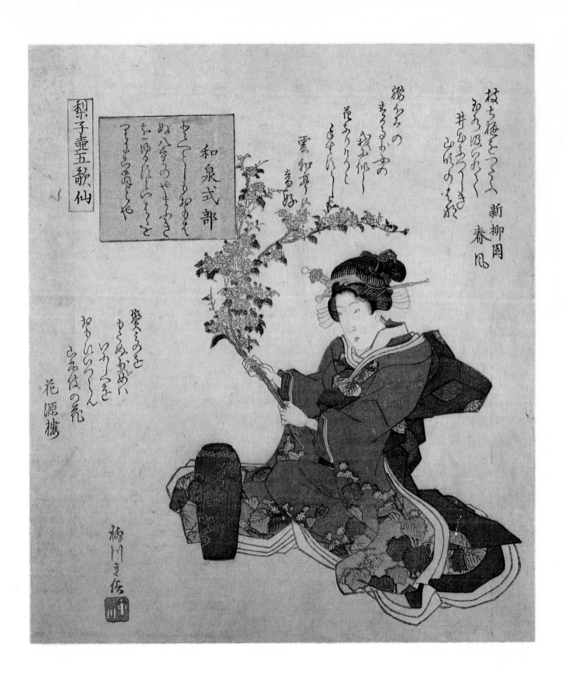

32. Girls collecting sea wrack. The girls work at dawn in the shallow sea near Fuji. Signed: Hiroshige *ga* (Andō Hiroshige). Size: 20.7 × 18.2 cm (8⅛ × 7¼ in.) Collection of the Museum für Kunst und Gewerbe, Hamburg.

33. Three servants leading a white horse. This Osaka surimono designed in winter, 1859, is much larger than surimono designed in Edo. Fifteen members of an Osaka art club have their amateur poems and names on the surimono. Signed: Baikadō Tōkyo-ka; seal, Matsukaze. Size: 39.5 × 52 cm. ($15\frac{1}{2}$ × $20\frac{1}{2}$ in.)

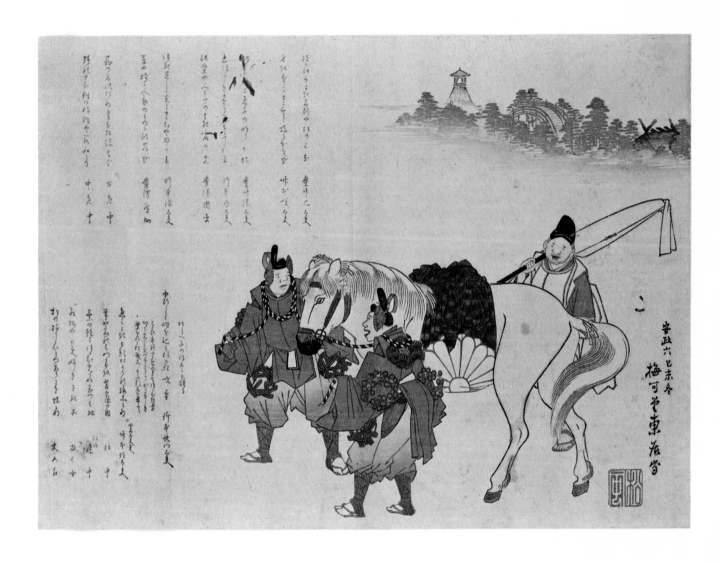

Appendix One
ERA NAMES AND DATES

Kan'en	寛延	1748–51		Tempō	天保	1830–44
Hōreki	寶曆	1751–64		Kōka	弘化	1844–48
Meiwa	明和	1764–72		Kaei	嘉永	1848–54
An'ei	安永	1772–81		Ansei	安政	1854–60
Temmei	天明	1781–89		Man'en	萬延	1860–61
Kansei	寛政	1789–1801		Bunkyū	文久	1861–64
Kyōwa	享和	1801–04		Genji	元治	1864–65
Bunka	文化	1804–18		Keiō	慶應	1865–68
Bunsei	文政	1818–30				

CHINESE-JAPANESE 12-ANIMAL CYCLE

Rat		1768	1780	1792	1804	1816	1828	1840	1852	1864	子
Cow		1769	1781	1793	1805	1817	1829	1841	1853	1865	丑
Tiger		1770	1782	1794	1806	1818	1830	1842	1854	1866	寅
Rabbit or Hare		1771	1783	1795	1807	1819	1831	1843	1855	1867	卯
Dragon		1772	1784	1796	1808	1820	1832	1844	1856	1868	辰
Snake		1773	1785	1797	1809	1821	1833	1845	1857		巳
Horse		1774	1786	1798	1810	1822	1834	1846	1858		午
Goat or Sheep		1775	1787	1799	1811	1823	1835	1847	1859		未
Monkey	1764	1776	1788	1800	1812	1824	1836	1848	1860		申
Cock	1765	1777	1789	1801	1813	1825	1837	1849	1861		酉
Dog	1766	1778	1790	1802	1814	1826	1838	1850	1862		戌
Wild boar	1767	1779	1791	1803	1815	1827	1839	1851	1863		亥

Appendix Three
ALPHABETICAL LIST OF ARTISTS

The name most familiar to Western readers is given first in its Romanized form; names in *kanji* characters are in the Japanese style, i.e., school or family name first.

Chōki, Eishōsai	栄松斎長喜	worked 1760's to 1810
Eisen, Keisai	渓斎英泉	1790–1848
Eishi, Hosoda	細田栄之	1756–1829
Eizan, Kikukawa	菊川英山	1787–1867
Gakutei, Yashima	八島岳亭	*ca.* 1786–1868
Harunobu, Suzuki	鈴木春信	*ca.* 1724–70
Hiroshige, Andō	安藤広重	1797–1858
Hokkei, Totoya	魚屋北渓	1781–1850
Hokuju, Shōtei	昇亭北寿	worked late 1790's to mid-1820's
Hokuma, Teisai	蹄斎北馬	1771–1844
Hokusai, Katsushika	葛飾北斎	1760–1849
Hokuïn, Katsushika	葛飾北雲	worked *ca.* 1805–40
Kazan, Watanabe	渡辺華山	1793–1841
Kiyonaga, Torii	鳥居清長	1752–1815
Koryūsai, Isoda	磯田湖竜斎	worked mid-1760's to 1780's
Kunisada, Utagawa	歌川国貞	1786–1864
Kuniyoshi, Utagawa	歌川国芳	1797–1861
Kyosen, Kikurensha	菊簾舎巨川	died 1777
Shigemasa, Kitao	北尾重政	1738–1820

Shigenobu, Yanagawa	柳川重信	1786–1832
Shinsai, Ryūryūkyo	柳々居辰斎	worked *ca.* 1790–1820
Shumman, Kubo	窪 俊満	1757–1820
Shunchō, Katsukawa	勝川春潮	worked late 1770's to late 1790's
Shun'ei, Katsukawa	勝川春英	*ca.* 1762–1819
Shunkō, Katsukawa	勝川春好	1743–1812
Shunshō, Katsukawa	勝川春章	1726–92
Shuntei, Katsukawa	勝川春亭	1770–1820
Toyoharu, Utagawa	歌川豊春	1735–1814
Toyohiro, Utagawa	歌川豊広	1773–1828
Toyokuni, Utagawa	歌川豊国	1769–1825
Toyoshige, Utagawa	歌川豊重	1777–1835
Utamaro, Kitagawa	喜多川歌麿	1754–1806
Zeshin, Shibata	柴田是真	1807–91

Appendix Four

PAPER SIZES OF WOODBLOCK PRINTS

Before the year 1800 and even later, surimono were small, e.g., 10.5×14 cm. (4×5½ in.) or 14×10.5 cm. (5½×4 in.); the largest measured approximately 18×12 cm. (7× 4¾ in.) Nineteenth-century surimono normally were *shikishiban*. The sizes are given in approximate measurements.

ōban (nishiki-e)	40×26 cm. (15¾×10¼ in.)
chūban	26×20 cm. (10¼×7¾ in.)
koban	20×14 cm. (7¾×5½ in.)
hashira-e	67×12 cm. (26½×4¾ in.)
hoso-e	30×15 cm. (11¾×6 in.)
kakemono-e	73×28 cm. (28¾×11 in.)
shikishiban (surimono)	20×18 cm. (7¾×7 in.)

Glossary

abuna-e: "dangerous," or suggestive, picture

aratame: appearing with artist's signature means "repeated" or "innovated"

Azuma nishiki-e: multicoloured picture printed in Edo

bakufu: government of the shōgun

baren: circular printing pad for taking impressions

beni: crimson, obtained from safflower

benigara: Indian red, or red oxide of iron, obtained from burnt green vitriol

benizuri-e: crimson red picture

Benten: the goddess of learning, speech, and love. She is the only female member of the Seven Gods of Good Fortune and is often pictured with a dragon.

bijin-e: picture illustrating a beautiful woman

biwa: a Japanese lute

chōji-iro: spice-brown pigment, a mixture of *seikō* and vermilion

chūban: medium-sized print

e or *-e:* picture

e-goyomi: calendar with picture

e-hon: picture book

Fudō (Fudō Myōō): a fierce god apparently of Indian origin (known as Acala in Sanskrit) who was neither a Buddha nor a Bodhisattva. Fudō is generally shown surrounded by flames and carrying a sword and rope to smite and bind evil.

fukujusō: the flower Adonis

ga: appearing after artist's name signifies "designed by" and/or "painted by"

gakō: appearing after artist's name signifies "designer and creator"

go: the national board game of Japan

gō: pseudonym used by an artist

gofun: white, made either from lead white or pulverized oyster shells

haitai jidai: decadent age

hanga: colour print

haru: spring

hashira-e: pillar pictures—long, narrow pictures pasted on house posts for decoration

131

hatamoto: samurai in the service of a shōgun

hatsu-: prefix meaning "first"

hatsu-yume: first dream of the year

higiga: erotic picture

hitsu: appearing after artist's name signifies "designed by" and/or "painted by"

hōsho: thick white Japanese paper

hoso-e: narrow picture

kakemono-e: hanging scroll picture

kashirabori: master carver

kibyōshi: cheap illustrated novelette in yellow binding

kihada: a shade of yellow

Kintarō: the "Golden Boy" who was brought up in the forest and grew to enormous strength.

kō: conceived by designer or artisan

koban: small-sized picture

koto: thirteen-string musical instrument

koyomi: calendar without picture

koyomi-ya: publishing house for calendars

kubarimono: article distributed free as a gift; *kubaru* means "to distribute"

kuchinashi: transparent yellow pigment, obtained from *Gardenia florida*

kusa-iro: grass green or dark green pigment, obtained by mixing *sekiō* and lilac

kusazōshi: collection of novelettes

kyōka: humourous or satirical poem

kyōka-bon: collection of comic poems

makura-e: erotic picture

manga: sketch, draft, cartoon

manji: Buddhist swastika

manzai: a comic drama form with two principal characters

mon: small monetary unit in use in the Tokugawa period

musha-e: picture illustrating warrior

Nagasaki-e: picture made at Nagasaki representing the Japanese view of the foreigners and their ships

ne no hi: day of the rat (zodiac)

ne no toshi: year of the rat. Other animals of the zodiac are: *ushi* (cow), *tora* (tiger), *u* (rabbit or hare), *tatsu* (dragon), *mi* (snake), *uma* (horse), *hitsuji* (goat or sheep), *saru* (monkey), *tori* (cock), *inu* (dog), *i* (wild boar).

nishiki-e: multicoloured picture

ōban: large-sized print

oiran: courtesan, prostitute

ōju: (painted) on request

okubi-e: picture illustrating the head, often including the upper torso

ren or *renjū:* society or club that cultivated the arts

Rochishin: one of the 108 heroes of the Chinese novel, *Suikoden.* He is easily recognized by his five-petal flower tattoo and heavy iron weapon.

ryaku-reki: abbreviated calendar

samisen: three-string musical instrument

sekiō: opaque yellow pigment, obtained from sulphur and arsenic

shikishiban: size of surimono of the 19th century

shiō: gamboge, a bright yellow pigment extracted from tree bark

sho: calligraphy

shu: Chinese vermilion, obtained from sulphuretted mercury

shunga: erotic picture

sumi: black, or Chinese ink

sumire: lilac pigment extracted from the *tsuyukusa* flower

surimono: pictures used as greetings on special occasions; *suru* means "to rub"; *mono* means "thing"

takara-bune: treasure-ship

tan: minium, a yellowish red pigment, obtained from lead oxide

tanka: poem with 31 syllables

tokonoma: recess in a Japanese room in which pictures are hung and flower arrangements and objets d'art are displayed

tsuyu-kusa: Commelina communis, a spiderwort

uguisu: nightingale

uki-e: picture employing perspective illustrating the interior of buildings

ukiyo-e: picture of the "floating" world; traditional woodblock print

ukiyo-e-shi: designer of *ukiyo-e* or woodblock prints

ukon: saffron pigment made from turmeric

ume: plum

yakusha-e: picture illustrating an actor

Yamato-e: pictures with Japanese characteristics developed during the Heian period

yanagi: willow

Yokohama-e: pictures produced after the opening up of Japan to foreigners

Yoshiwara: name of the licensed quarter in Edo, the so-called nightless city

Annotated Bibliography

IN ENGLISH

Binyon, Lawrence and Sexton, J. J. O.: *Japanese Colour Prints,* Faber and Faber Ltd., London, 1960
> Contains 280 pp.; 48 illustrations including 16 in colour. Short references to surimono and the designers.

Chiba, Reiko: *The Making of a Japanese Print,* Charles E. Tuttle Co., Tokyo, 1959
> This little book shows Hokusai's colour print, *The Heron Maid,* which was printed with ten woodblocks.

Forman, W.: *Hokusai,* Artia, Prague, 1956
> Contains 115 pp.; 45 illustrations including 7 surimono.

Hillier, J.: *The Japanese Print: A New Approach,* Charles E. Tuttle Co., Tokyo, 1960
> Contains 184 pp.; 64 black-and-white illustrations. Surimono treated in detail in Chapter XI.

Hirano, Chie: *Kiyonaga, A Study of His Life and Works,* Museum of Fine Arts, Boston, 1939
> Mention is made of 13 surimono by Kiyonaga.

How to Make Colour Prints, Yoshikawa Shoten, Yokohama, 1935
> The process of making colour prints is illustrated with 20 woodblocks; the last shows the finished colour print.

Kōdansha Library of Japanese Art, Charles E. Tuttle Co., Tokyo, 1955–59

Booklets on artists such as Kaigetsudō, Hiroshige, Kiyonaga, Sharaku, and Utamaro are well illustrated and inexpensive. Also in Japanese by Kōdansha.

Michener, James A.: *The Floating World,* Random House, Inc., New York, 1954
Contains 403 pp.; 63 illustrations, most of them in colour.

————: *Japanese Prints,* Charles E. Tuttle Co., Tokyo, 1959
Contains 287 pp.; 257 illustrations, most in colour. The book contains many beautiful illustrations and valuations of the artists. There is not much regarding surimono except the mention of artists who also designed surimono.

Munsterberg, Hugo: *Landscape Painting of China and Japan,* Charles E. Tuttle Co., Tokyo, 1956
Contains 143 pp.; 101 illustrations including 32 from Japan, but no surimono.

Narazaki, Muneshige: *The Japanese Print, Its Evolution and Essence,* (adapted by C. H. Mitchell), Kōdansha International, Ltd., Tokyo, 1966
Contains 274 pp. and 107 plates, including a good index and glossary.

Society of Friends of Japanese Arts: *Index of Japanese Painters,* Charles E. Tuttle Co., Tokyo, 1958
This useful book gives artists' names, family names, and pseudonyms of nearly all important ukiyo-e artists.

Strange, Edward F.: *The Colour Prints of Japan,* Siegle, Hill & Co., London, 1910
This book was published as the second volume of the Lingham series of art monographs. Pages 66–78 of chapter 10 are on surimono.

————: *Japanese Colour Prints,* Victoria and Albert Museum, London, 1911
Contains 143 pp.; text, 21 pp. plates and register. It includes 77 illustrations, but only 1 illustration and 8 pages of text on surimono.

Takahashi, Seiichirō: *Japanese Woodblock Print—250 Years,* Chuō Kōron/Bijutsu Shuppan, Tokyo, 1965
Contains 161 pp.; text, 59 illustrations. There is a good bibliography and 18 essays on woodblock prints. Unfortunately there is no index and nothing on surimono.

IN GERMAN

Brinckmann, Dr. Julius: *Kunst & Handwerk in Japan,* R. Wagner, Berlin, 1889
Contains 299 pp.; pp. 291–94 on surimono.

Hempel, Rose: *Holzschnittkunst Japans*, Chr. Belser, Stuttgart, 1963
Contains 256 pp. and 110 colour plates. The 18-page introduction deals with history and technique of woodblock prints.

————: *Japanische Holzschnitte*, Museum für Kunst & Gewerbe, Hamburg, 1961
Contains 70 pp.; 40 black-and-white illustrations.

Kurth, Julius: *Der Japanische Holzschnitt*, R. Piper & Co., Munich, 1921
Contains 172 pp.; 88 illustrations and a list of printing-block carvers.

————: *Suzuki Harunobu*, R. Piper & Co., Munich, 1906
Contains 121 pp.; 54 illustrations.

————: *Utamaro*, F. A. Brockhaus, Wiesbaden, 1907
Contains 390 pp.; 45 colour and black-and-white illustrations.

Lewin, Bruno: *Das Weib des Yoshiharu*, Verlagsanstalt Hermann Klemm, Erich Seemann, Freiburg, 1957
Translation of Santō Kyōden's book *Sakura-Hime Zenden Akebono Zōshi*, a story of love and adventure in 13th-century Japan. There are 16 woodblock prints by Utagawa Toyokuni.

Meister, Dr. P.: *Acht Surimono*, Waldemar Klein Verlag, Baden-Baden, 1958
Contains 15 pp.; 8 colour reproductions of surimono.

Praetorius, Emil: *Zehntausendfaches Glück*, R. Piper & Co., Munich, 1959
Contains 45 pp.; 16 beautiful reproductions of surimono by Hokusai and Hokusai's pupils,; 9 pp. epilogue.

Robinson, B. W.: *Kuniyoshi*, Burkhard Verlag, Essen, 1963
Contains 33 pp.; 33 colour plates, introduction by Werner Speiser, 2 pp. bibliography. Unfortunately there is nothing on Kuniyoshi's surimono.

Rumpf, Fritz: *Meister des Japanischen Farbenholzschnittes*, Walter de Gruyter & Co., Berlin, 1924
Contains 143 pp.; text, 15 plates, 70 illustrations. Rumpf, an expert on Japanese theatre history, has the merit of correcting many mistakes and misunderstandings which the first pioneers in ukiyo-e history unavoidably had made.

Seckel, Dietrich: *Andō Hiroshige, Tokaidō Landschaften*, Waldemar Klein Verlag, Baden-Baden, 1958
Contains 16 colour reproductions of Hiroshige's famous 53 stations. There is a 20-page introduction by Dietrich Seckel and 4 pp. of his comments to the plates.

Seidlitz, Waldemar von: *Geschichte des Japanischen Farbenholzschnitts,* Wolfgang Jess, Dresden, 1923
Contains 233 pp., including 6 pp. bibliography. On page 16 there is one paragraph and on page 201 one reproduction of a surimono.

Speiser, W.: *Kuniyoshi,* Museum für Ostasiatische Kunst, Cologne, 1963
Contains 32 pp. and 12 illustrations. Description of 128 exhibited prints by Kuniyoshi, but none of Kuniyoshi's 5 surimono are mentioned.

Speiser, W. and Netto, W.: *Kunisada,* Museum für Ostasiatische Kunst, Cologne, 1965
Contains 40 pp.; text and 20 pp. illustrations. The text includes the description of 5 surimono.

Succo, Friedrich: *Katsukawa Shunshō,* C. F. Schulz & Co., Plauen, 1922
Contains 145 pp.; text, 55 illustrations. Nothing on surimono.

————: *Utagawa Toyokuni und seine Zeit,* R. Piper & Co., Munich, 1924
Contains 147 pp.; 154 illustrations. There are 6 colour plates including 2 surimono on pp. 87 and 108.

IN JAPANESE

Kikuchi, Sadao: *Ukiyo-e,* Hoiku-sha, Osaka, 1965
Contains 153 pp.; 95 illustrations.

Mizoguchi, Yasumaro: *Ukiyo-e-shi Torii Kiyonaga,* Mito Shoöku, Tokyo, 1962
Contains 82 pp.; 72 illustrations plus 110-page catalogue.

Noma, Seiroku and Tani, Shin'ichi: *Nihon Bijutsu Jiten,* Tōkyōdō, Tokyo, 1958
Contains 726 pp.; 16 plates and more than 1,000 small illustrations in the text. 31 pp. register of personal names and 8 pp. art vocabulary. This is a dictionary for all Japanese art.

Sekai Meiga Zenshū, No. 22 Nippon, Heibonsha, Tokyo, 1959
Contains 105 pp.; 111 illustrations. Nothing on surimono.

Shimizu, Fudaku: *Ukiyo-e Jimmei Jiten,* Nihon Bijutsu Club, Tokyo, 1964
Contains 160 pp.; text, 36 illustrations. This is a dictionary containing the names and data of many but not all ukiyo-e and surimono artists. The appendix includes a 12-page list of artists and 46 pp. illustrations by modern woodblock artists.

Shimonaka, Yasaburō: *Ukiyo-e no Sekai* (No. 22 of Heibonsha's book series Masterpieces of the World), Heibonsha, Tokyo, 1961
Contains 105 pp.; 111 illustrations, most of them in colour.

Ukiyo-e, Gabundō, Tokyo, No. 1, 1962, to No. 19, 1968
 Three or four editions issued yearly. This periodical contains essays on woodblock prints and their artists by Japanese experts (in Japanese) and occasionally essays by foreign specialists (in English). Almost all of the illustrations are in black and white.

Yoshida, Teruji: *Ukiyo-e Jiten,* Ryokuen Shobō, Tokyo, 1965
 Vol. I and II: 808 pp. and approximately 2,400 small illustrations in the text. This large dictionary was planned for three volumes; Vol. I (405 pp.) and Vol. II (403 pp.) have been published. Up to the *kana* syllable *sa* has been completed thus far, so that about 50 percent of Yoshida's work is finished.

————: *Ukiyo-e no Bi,* Sōgensha, Tokyo, 1960
 Contains 216 pp.; 129 illustrations.

————: *Ukiyo-e no Nyūmon,* Ryokuen Shobō, Tokyo, 1962
 Contains 433 pp.; 129 illustrations.

IN FRENCH

Gonse, Louis: *L'Art Japonais,* Librairie-Imprimeries Reunies, Paris, 1886 and 1888
 Contains 334 pp., including 21 pp. on woodblock prints and 2 pp. on surimono.

Index